DARE
TO CREATE

For Douce, who has always encouraged my creativity.

Dare to Create: 35 Challenges to Boost
Your Creative Practice
Marie Boudon

Editor: Kelly Reed
Translation: Marie Deer
Copyeditor: Barbara Richter
Proofreader: Linda Laflamme
Graphic design and layout: Julie Simoens
Production layout: Gary Hespenheide
Project manager: Lisa Brazieal
Marketing coordinator: Mercedes Murray

Cover: Studio Eyrolles © Éditions Eyrolles
Cover illustrations: © Marie Boudon (except top right:
© Photographee.eu / Shutterstock)

All illustrations and photographs are by the author,
except as noted here:
Amy Anderson: p. 93 (portrait);
Courtney Cerruti: pp. 27, 61, and 62;
Danielle Krysa: pp. 78 (bottom), 79, and 86;
Deeann Rieves: p. 127;
Deeann Rieves/Lauren Carnes photography: pp. 113,
 116, and 117;
Eduardo Pavez: p. 182 (portrait);
Emma Block: pp. 159 and 160;
Fran Meneses: pp. 120, 182 (bottom), and 183;
Ira Sluyterman van Langeweyde: pp. 64 (bottom), 65,
 and 156;
JJ Ignotz Photography: p. 46;
Jordan Matter: pp. 47 and 178;
Josie Lewis: pp. 43, 93 (bottom), 94, and 95;
Kiana Underwood/Tulipina: pp. 162 and 163;
Laura Gilli: pp. 132 and 133;
Lisebery: p. 170 (top); Liz Daly: p. 26;
Marie-Charlotte Photographie: p. 171 (bottom);
Minnie Small: pp. 150, 151, and 152;
Noémi Micheau: pp. 49 and 192;
Pacco: pp. 101, 102, 103, and 165;
PV Nova: p. 134;
Shari Blaukopf: p. 34;
Stefan Oberholz: p. 64 (portrait);
Stephanie Seaton: p. 78 (portrait);
www.jenesaispaschoisir.com: p. 171 (top);
Yao Cheng Design LLC Christa Kimble Photography
 (christakimble.com): pp. 35, 89, 125, and 126.

ISBN: 978-1-68198-735-4
1st Edition (1st printing, March 2021)

Original French title: J'ose créer
© 2019 Éditions Eyrolles, Paris, France
75240 Paris Cedex 05 www.editions-eyrolles.com
French ISBN: 978-2-212-67691-4

Rocky Nook Inc.
1010 B Street, Suite 350
San Rafael, CA 94901
USA

www.rockynook.com

Distributed in the UK and Europe
 by Publishers Group UK
Distributed in the U.S. and all other territories
 by Ingram Publisher Services

Library of Congress Control Number: 2020949312

Marie Boudon
tribulationsdemarie.com

DARE TO CREATE

35 Challenges to Boost Your Creative Practice

CONTENTS

INTRODUCTION

At the beginning of 2015, I felt the need to reconnect with my creativity, which I had completely set aside for a long time. At the time, I was an engineer, and it wasn't that easy to reconcile my work with my budding passion for watercolors. I was teaching myself, and I often felt lost: Where should I start? How should I move forward? How should I organize myself? How could I find my own style? Most of the time, these questions kept me from moving forward, and I spent entire weeks at a time just thinking about the best way to do things.

In order to find help and suggestions, I read a lot of books and listened to a large number of podcasts on creativity, art, and personal development. I was hoping for a look behind the scenes at artists' practices, in any field. Very few shared their secrets, because a person's artistic practice is very personal and involves their intimate life, or because revealing themselves that way would have threatened their uniqueness. And yet, everything I learned about an artist's organization, inspiration, confidence, habits, or personality nurtured my own art much more than any technical advice on mixing pigments would have done. I understood that these ideas had to do with the creative process, and my new goal was to develop my own in a holistic way. The American photographers and writers David Bayles and Ted Orland, in their book *Art & Fear, Observations on the Perils (and Rewards) of Artmaking*, write: "We are taught to paint, but not really to paint our own paintings."

In 2016, I moved from theory to practice. Internalizing the pieces of advice that I had gathered and gradually experimenting with them was much more revealing to me than theory: it allowed me to feel things. I understood that advice on creativity fell into two very different categories:

◐ the category of Organization, including the keywords:

order, planning, research, iterations, mastery, meticulousness, repetition, orchestration, cerebral

◐ the category of Spontaneity, including the keywords:

intuition, experimental, risk, raw, chaos, improvisation, visceral, sensations

As a project manager, I was, of course, more comfortable with the advice that fell into the category of Organization, and I was reassured to see that many artists practiced their art in a disciplined way. When I finally decided to accept and draw on the scientific side of my personality—which I had thought was contrary to my creativity—I was able to benefit from what I could learn from my professional life, specifically the tools of time management and task tracking, and I made a great leap forward. At the same time, I was aware that [p. 6] I also had to exercise the spontaneous side of my creative process. It was harder for me to let go so that I could improvise or experiment. But I realized that when I did, that opened up a new field of pos-

sibilities. After about a year, I started combining these different abilities and creating my own practice.

This kind of approach is thrilling, because your result (a final product) is less important than the total adventure. Exercising your creative process is a constant renewal, and it gives an entirely new dimension to an artistic practice.

I decided to write this book so that I could share this journey and help guide you on your own creative path, from your first self-doubts to the affirmation of your voice. This book is the fruit of my experiences but, especially, of a lot of research, in particular with some fascinating artists, whose own words and personal stories you will find over the course of these pages.

Whatever level you are at (beginner or expert), and whatever your artistic practice (photography, drawing, painting, collage, etc.), this book will accompany you as you practice your art and also guide you in your mental practice, which is essential to your progress.

How should I read this book?

This volume is made up of thirty-five challenges. Each of them uses a variety of methods (ranging from very deliberate to very spontaneous) and encourages you to practice. And going beyond the reading, your own activity will allow you to discover the methods that work best for you.

The challenges follow the natural progression of an artist's path. Thus, I suggest that you first read the book once through in order. Then, after having accumulated some creative experience, you will probably return to some of the challenges with a new perspective.

These challenges are just a beginning: listen to yourself and allow yourself the time to put together the various bricks that this book offers you into your own path. Get ready to learn a lot about your art and about yourself so that you can let your creativity blossom!

ACCEPTING YOURSELF

Painting, drawing, photography, calligraphy, collage....
One or more of these artistic practices interests you, but
"it's not your thing." What is keeping you from getting
started? "I don't have time. I don't have any talent...." The
list of excuses is long and justified—it's true that our busy
daily life doesn't leave a lot of room for creativity.

Everybody has their own blocks, but they all come from
the same place: the fear of the unknown. Creating means
accepting the unknown and leaving your comfort zone:
it's frightening. You're not happy about being blocked,
but you'd rather wait for a better time instead of than
getting started now. Will that time ever come? In fact, this
state of creative blockage is harder to live with than the
highs and lows of the practice of your art. Know that, as
Elizabeth Gilbert writes in her book *Big Magic: Creative
Living Beyond Fear*, "Creative living is a path for the
brave." This first part of the book will help you to accept
yourself by confronting your doubts, which will seem very
small and silly once you have made the leap!

Giving yourself PERMISSION to create

YOU WANT TO CREATE, BUT MAYBE YOU THINK THAT IT ISN'T FOR YOU. YOUR AGE, YOUR TRAINING, OR YOUR DAILY LIFE GET IN THE WAY. WHAT A SHAME! WHATEVER YOUR SITUATION, IT'S TIME FOR YOU TO GIVE YOURSELF PERMISSION TO CREATE. IN THIS CHALLENGE, I PROPOSE THAT YOU DECIPHER THE BARRIERS THAT ARE KEEPING YOU FROM BEING CREATIVE AND OVERCOME THEM USING POSITIVE AFFIRMATIONS.

"Creativity is not my thing"

No matter how old you are or what your history or education is, you can teach yourself a new creative discipline and have fun doing it. The French American sculptor and visual artist Louise Bourgeois had her greatest successes after she turned seventy. She kept creating things in her Brooklyn studio until she was ninety-eight years old, saying, "Art is a guarantee of sanity." The only condition you need to fulfill in order to be able to create is just to get started.

The life you have lived will nurture your art. In my case, I was afraid to think of myself as an "artist" because of my training as an engineer. I thought that I was too rational, too technical, too deliberate. Calling yourself an artist seems taboo, like something reserved for a very select group. People often prefer to say something like "I paint." And yet, as the Israeli painter and writer Jonathan Kis-Lev writes in his book *Masterwork*, "You should be the first to be proud of your work and to talk about it." Like me, decide to accept all of the facets of your personality and jump in!

> "There is no trap so deadly as the trap you set for yourself."
> —Raymond Chandler, American novelist, poet, and screenwriter, in *The Long Goodbye*

The influence of your childhood and your environment

When you were little, were you encouraged to create? For children, exploring their creativity comes naturally, and they don't feel embarrassed about it. The creative life you had as a child influences your adult creative life and plays a role in your blockages. In your childhood, people may have said apparently innocuous things to you like, "Oh, you're better at math than drawing, aren't you?" Things like that may have left their mark on you, inhibiting you in your creative practice.

Now, distance yourself from this kind of (often unintentionally) hurtful remark. Reconnect with your childhood soul and rediscover your desire to learn and your inborn confidence.

It's up to you to decide

Why not try to create? Don't be tied down by your own expectations or those of the people around you. Just give yourself permission to start: don't put yourself in a box, and don't underestimate your creative abilities. Do you like to write, do interior decoration, garden, cook, suggest new ideas at work? Then you are already being creative in your daily life. Don't wait for someone to tell you, "Yes, you're an artist"—decide for yourself.

If you're not creating, fate is probably not to blame. Something deep down inside you is stopping you. The decision of whether to get started or not is all yours. Unlearn everything you think you know about your own creativity. "If you hear a voice within you say 'you cannot paint,' then by all means paint and that voice will be silenced," was Vincent van Gogh's advice. After all, can you really do without your creativity? If you continue to keep it tucked away, hidden within you, it could make you sick.

"The world needs you. We need your inspiration. We need your creations. And even if someone has told you otherwise, there is room for you. You just have to get started."

—Jonathan Kis-Lev, Israeli painter and writer

"Your creativity doesn't depend on anyone but you."

- Jim Leonard, American writer

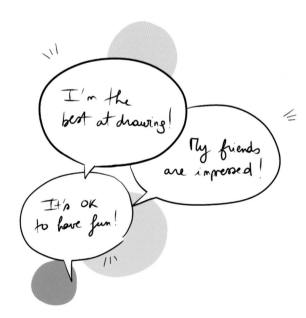

Your Turn

In order to allow yourself to be creative, you are going to use affirmations. These are short, positive statements that you say out loud in order to encourage yourself. Some writers, like Julia Cameron (*The Artist's Way*) and Hal Elrod (*The Miracle Morning*) emphasize that affirmations can reprogram you completely, giving you a burst of confidence. Your final blocks will fall away, and you will break free from the gaze of others. I have used affirmations every day for more than a year, and it has undeniably given me the confidence to create and even to start my own business.

1. **List your main creative blocks. For example: "I was not made to be creative"; "My friends will judge me"; or "I have better things to do."**

2. **Transform these negative thoughts into affirmations. Project yourself into the future as if you were already there. For example: "I excel at drawing"; "My friends will be so impressed that they'll be asking for my autograph"; "I have the right to have fun." Write your affirmations down in a notebook, as a phone memo, or on a Post-it. The goal is to be able to easily find and reread them.**

3. **Every day, repeat these statements several times in a row, preferably out loud, while visualizing yourself in the near future.**

You can use this technique throughout your creative adventure to help yourself get past obstacles.

Defining YOUR PRIORITIES

NOW THAT YOU ARE CONVINCED THAT YOU CAN CREATE, YOU ARE GOING TO COME UP AGAINST THE EXCUSE THAT WILL HOLD YOU BACK THE MOST OFTEN: "I DON'T HAVE TIME!" YOU HAVE DEFINITELY ALREADY USED IT AT LEAST ONCE. THERE ARE TWO EXPLANATIONS FOR WHY THE CALENDAR DOESN'T LEAVE ROOM FOR CREATIVITY: EITHER YOU HAVE MORE IMPORTANT THINGS TO DO, OR YOUR SCHEDULE IS OUT OF YOUR CONTROL—IT FILLS UP FAST WITHOUT YOU REALLY KNOWING WHY. THIS CHALLENGE INVOLVES IDENTIFYING YOUR PRIORITIES SO THAT YOU WILL BE ABLE TO BETTER MANAGE YOUR TIME.

Creating a mind map

To start with, I suggest that you identify your priorities using a mind map. This tool will allow you to easily visualize and organize a large amount of information. The pieces of information are arranged spatially around a central core, which is the theme of the mind map. In the context of this challenge, the theme will be your daily activities. This exercise will allow you to take stock of the activities that you do regularly and, by contrast, those to which you do not dedicate yourself often enough.

Take a sheet of paper and write your name in the middle of it. Then draw bubbles around your name. In the bubbles, write your main activities, as well as the ones that you would like to be doing: work, exercise, family time, cooking, being creative, organizing, relaxing, planning and prepping, going out with friends, traveling.... You can also break out sub-categories of activity; it's up to you to choose the level of detail you want your mind map to reflect.

Now choose three colors, corresponding to three levels of priority: high, medium, and low. Color in the bubbles of your mind map according to the importance that you want to assign to each activity.

Not all activities are equally important. Defining your priorities will allow you to determine which activities you want to concentrate on. The fact that you have bought this book means that creative activities are probably one of your high priorities. It isn't a bad thing if certain activities have a very low priority for you at a certain point in your life. The order of your priorities will change over time.

The activities of my daily life are broken down into sub-categories. My priority levels are indicated by colors as follows: white for high priorities, green for medium, and pink for low.

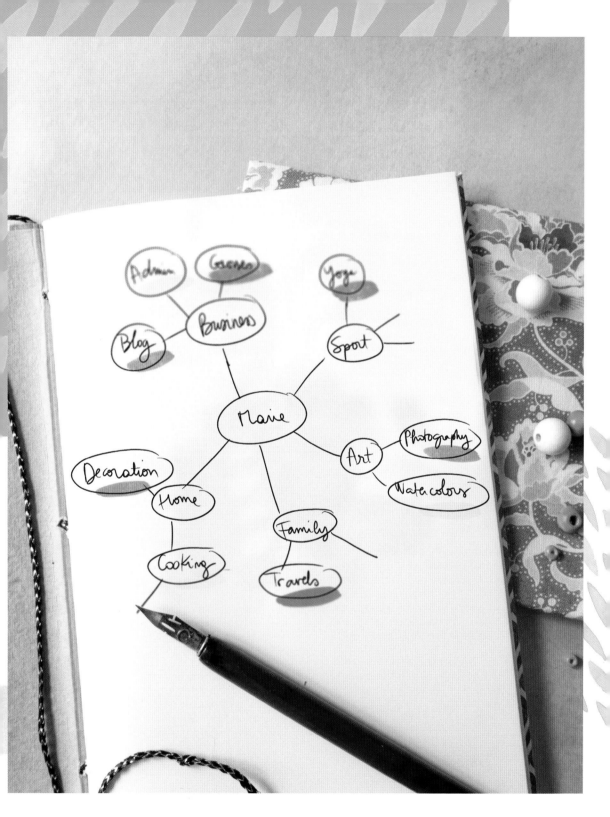

Taking a hard look at your priorities

Now that you can visualize your priorities, are you able to include all of them in your schedule? Here are several common situations; you might recognize yourself in one or more of them.

◊ **Your daily life is filled with chores of medium to low importance that you feel obligated to take care of.** As Julia Cameron describes in her book *The Artist's Way*, many blocked creative people are Cinderellas of our modern world. They concentrate on other people at their own expense, and it can even be frightening to them not to be useful for once. Finding time for yourself is not selfishness. If you want to have a creative practice in your life or to create more, dare to say no more often to less-important tasks so that you can spend some time on your creative activity.

◊ **Everything is a priority for you: your work, your family, creativity, travel....** If you have too many priorities, you will be frustrated because you can't manage to do everything. Life is made up of seasons, and it is normal not to be able to concentrate on everything important at the same time. Choose a more reasonable number of priorities, or failing that, aim to create small regular time slots, even just a few minutes, for each activity (challenge 3).

◊ **You put your priorities off to tomorrow (you procrastinate) because you are too tired to get started.** As the American writer and lecturer Denis Waitley puts it, "Most people spend most of their time on low-priority busywork because it requires no additional knowledge, skills, or imagination—or courage. In a word, it's easier."

The American personal development author and lecturer Stephen Covey gives the following example as a way to better visualize the importance of ordering your priorities.

Imagine a jar, and three kinds of stones: large, medium, and as small as grains of sand. The jar is a metaphor for your daily life. The size of the stones represents the importance of your priorities. You can fill the jar in two different ways:

◊ You can put the sand in first, then the medium-sized stones, and then the large ones; but it will probably not be possible to fit everything into the jar.

◊ Or, alternatively, imagine that you fill the jar first with the large stones, then with the medium ones, and finally with the sand: then everything will fit into the jar.

This metaphor shows that if you give your time first to the things that are most important, it will be easier for you to devote yourself to the less important tasks after that; but if you do it the other way around, it won't work.

"The key is not to prioritize what's on your schedule, but to schedule your priorities."

—Stephen Covey, American personal development writer and lecturer

 your Turn

In order to identify your priorities and bring your creative practice to the fore:

1. Do the mind map exercise in order to identify the activities of your daily life and the activities that you are interested in.

2. Define the order of priority for these activities by using different colors (for high, medium, and low priority).

3. For every high-priority activity, ask yourself whether or not it has a place in your schedule. In challenge 3, you will see in detail how to find time for these activities.

finding TIME

NOW THAT YOU HAVE REDEFINED YOUR PRIORITIES AND MOVED CREATIVITY TO THE TOP OF THE LIST, IT IS TIME TO GIVE IT A DEDICATED TIME SLOT IN YOUR SCHEDULE. OTHERWISE, IT WILL BE HARDER TO FIND TIME TO ACTUALLY ACCOMPLISH WHAT YOU WANT TO DO. THE OBJECTIVE OF THIS CHALLENGE IS TO IDENTIFY THE MOMENTS THAT ARE AVAILABLE FOR CREATIVE ACTIVITY. YOU MAY BE SURPRISED BY HOW YOU CAN OPTIMIZE YOUR TIME. THIS EXERCISE OPENED MY EYES TO THE POSSIBILITIES THAT WERE AVAILABLE TO ME AND COMPLETELY CHANGED MY CREATIVE PRACTICE.

Making your planner work for you

The hectic pace of our everyday lives makes us feel like our schedule is permanently overloaded. It's not that easy to recognize how we are using our time on a detailed level. Every day is made up of twenty-four hours, but why do some of them seem to have more time in them than others? You, too, can make your calendar or daily planner into a definite asset by using the following:

◊ **a strong vision of your priorities:** you spend time on what really matters.

◊ **a little bit of discipline:** you stick to your decisions and avoid putting things off till tomorrow.

◊ **concentration:** you don't require more time than is necessary to complete a task, and this notion of productivity sets off a virtuous cycle.

When I first discovered these pieces of advice, I understood that the way in which I organized my entire day had an effect on my creative time. If I was more productive throughout the day, I was less exhausted in the evening. I had the feeling of having been efficient, and so I had more mental space for starting to create.

Analyzing your schedule

Other people don't necessarily have more time than you do. If you allow yourself to reevaluate your schedule and your organization, you may open up new time slots. For one week, try the following exercise.

In a notebook, or on your smartphone, describe the main time frames of your week: what time you wake up, when you start getting ready, when you go to work, when you eat lunch, what time you come home, what you do in the evening.... Be precise and truthful about the reality of your daily life.

When I did this exercise, it was a revelation for me. I used an app to analyze my time in detail. I chose Rescue Time (available on Mac, PC, iOS, and Android), which I installed on my computer and on my smartphone, but there are others available as well, such as Moment (iOS). The app works in the background of your device and registers everything you do, both offline and online. It allowed me to know exactly how much time

I spent on which sites, in which computer applications, and on which phone apps. Given that I work on my computer 95 percent of the time and I have somewhat of an addiction to my phone, I knew that this analysis would show me whether or not I was tending to waste time.

I decided to keep going with the analysis for an entire month, and while I was already engaged in creative activities for several hours every week, I got my answer about how I was spending my time. In one month, I had spent more than twenty-one hours on YouTube, twelve hours on Instagram, seven hours on Facebook, six hours on my personal email, and four hours on Pinterest. Of course, I needed some relaxation time, but did I really have to spend more than fifty hours online? Couldn't I have managed to find some time for creativity instead? This realization was a definite shock. That's when I understood that it was up to me to get organized to manage my time better. The fact that my schedule was full wasn't anyone else's fault, but a result of my own choices.

Choosing a time slot

Did you learn something from the analysis of your time? Identify the moments that you could dedicate to your creative activity. Mornings, midday, evenings, the weekend? In my case, after having been creative in the evenings after I got home from work, I tried using the mornings instead (which involved getting to bed earlier), and I liked that better. Try out various configurations to discover what suits you best. How much time can you dedicate to your art every week? Ideally, start with half an hour per week if you can't do more. This will be more helpful than just one two-hour chunk of time per month, because you will be starting a routine (see challenge 18). You might try a bullet journal to set up and track your creative sessions. The bullet journal, which has been very popular since 2014, is a method created by Ryder Carroll, an American designer and writer, that is halfway between a diary and a to-do list. The idea is to write down in a notebook your tasks and meetings over multiple time frames (day, week, month). You are encouraged to use a pagination system in order to find your way around within the notebook, and specific symbols for tracking tasks that are finished, in progress, or to be postponed, for example. The method is very easily customizable; people who are more visual like to decorate their notebooks, making them even more attractive.

> "*When you're passionate about something, not having time is meaningless.*"
> —Author unknown

It's perfectly realistic to be able to find half an hour a week in which to create. If you can't manage that, then being creative is probably not a priority for you, or else you have lost interest in your creative activity. If you find it impossible to dedicate time in your schedule to your creativity, have you asked yourself whether it would be possible, or even bearable, to survive without it? Lisa Ferber, a multimedia artist in New York, talked about this issue in an article in the *Huffington Post* in 2012: "What I found is that if you're overworked, making art can revitalize you. Once you stop using time as an excuse, you can figure out what needs to be cut out. Find something that can be cut out just to give yourself a full hour. You owe it to yourself to celebrate that creative world inside you."

As for me, after years of putting my creativity aside, I felt unhappy. I had to create. It was a necessity. There was a part of me that needed to be expressed. I felt better, more complete, when I had a creative time slot in my week. Who cared if it took more organization and discipline? It was essential to me. Is that how it feels for you?

 your Turn

Look at your schedule again with this challenge.

1. Analyze how you spend your time, over the course of anywhere from a week to a month, by taking notes or by using an app like Rescue Time. Ideally, write down the main activities of your days hour by hour, without trying to change your habits.

2. Identify the activities that are not priorities for you and that take the most time.

3. Choose a time slot of at least thirty minutes per week for creating. Try different times if you aren't sure about your choice (mornings, middays, evenings, weekends, etc.). Ideally, this time slot should be about the same every week so that you can start to establish a routine. (We will return to this idea in challenge 18.)

Building YOUR CONFIDENCE

YOU HAVE GIVEN YOURSELF PERMISSION TO CREATE, AND YOU HAVE ESTABLISHED A TIME SLOT FOR THAT. NOW YOU NEED TO REINFORCE YOUR SELF-CONFIDENCE BY PUTTING YOUR CREATIVE PROJECT INTO PRACTICE. YOU MAY SUFFER FROM IMPOSTOR SYNDROME. THIS CAN BE SEEN IN THE ABILITY TO CREATE A SERIES OF EXCUSES, INCLUDING "I'M NOT READY"; "OTHER PEOPLE CAN DO THIS BETTER"; "I DON'T HAVE ANY TALENT"; AND SO ON. THIS CHALLENGE CONSISTS OF DISMANTLING THIS LACK OF CONFIDENCE BY UNDERTAKING A VERY SIMPLE PROJECT, BUT ONE THAT MARKS THE BEGINNING OF A GRAND ADVENTURE!

Get rid of excuses

"I'm afraid of doing something pathetic. I'm going to fail. I'm not ready."

No one is ever ready to face the unknown and to create. Choose courage instead of comfort. Now is the best time to start. Follow the advice that Steven Pressfield gives in his book *The War of Art*: "Are you paralyzed with fear? That's a good sign. Fear is good. Like self-doubt, fear is an indicator. Fear tells us what we have to do. Remember one rule of thumb: the more scared we are of a work or calling, the more sure we can be that we have to do it."

> "Leap and the net will appear."
>
> —**John Burroughs, American naturalist and essayist**

"Everyone else is better than me." "I'll never be as good as they are."

There is no point in comparing yourself with other people or spending hours consuming content instead of creating your own. There will always be someone more creative, more successful, richer, or smarter than you. Accept it and concentrate on your passion. It is your individuality that will allow your art to stand out. Like Daniella Krysa (personal story, page 78), channel your jealousy and transform it into motivation.

"I have no talent."

It is hard to comprehend the amount of work that is necessary in order to reach a certain artistic level. Never judge an artist by saying that they are successful only because of their talent. It is probably the fruit of thousands of hours of work. Talent alone is not enough for building a large body of work; you also have to work at it and practice your creativity. Picasso left behind some 120,000 works, according to the movie *Picasso*,

the *Legacy*, directed by Hugues Nancy, and more than 600 compositions by Mozart have been catalogued. Of course, these artists were talented, but they also did an enormous amount of work. Don't try to create masterpieces, but rather make a point of working on the quantity of your artistic creations (challenge 17).

> "*Interest and dedication, more than talent, were the determining factors in almost everything I have done in my life.*"
> —Shaun McNiff, American artist, writer, and art therapy teacher

"I have no style of my own. All I know how to do is copy."

Don't worry about style for now. You don't need style in order to start creating. As you practice, your style will assert itself naturally. Style is a result rather than a goal; it is a combination of your favorite techniques, your influences, and your experimentation. Concentrate on the practice and experiment while following your curiosity (challenge 10); you will discover your style at a later stage (challenge 31).

Gaining self-confidence

It is up to you to decide to believe in your ability to improve and in your ideas in order to get past all these self-doubts. Give yourself the opportunity to experiment. A blocked state is harder to live with than a "failed" creation. What matters most of all is having fun. You don't have to show everything that you make, especially not on social networks (and certainly not right away). Create slowly, at your own rhythm, in order to please yourself. Creativity is unlimited; you can't use it up, and it is not ONLY there for other people. Be your own first fan. Believe that everything is there for a reason and that everything will happen for you in time. If you feel like you still have complexes, go back to challenge 1. However, I think that the best way to gain confidence is just to take a first small step.

"Everything starts from a dot."
—**Wassily Kandinsky**

Your Turn

With this challenge, we say goodbye to excuses and sterile creative reveries—it's time to take action! Reading advice is not enough. You have to act and try things out in order to gain confidence.

1. What kind of creative materials do you already have at your disposal? Open up your cupboards and drawers and take out everything that inspires you (colored pencils, paints, magazines, glue...). You could also just use the camera in your smartphone or a paper and pen. That's enough to start creating with!

2. Start something, even if it's very small and has no connection with the creative practice that you are drawn to. The goal is simply to start: draw geometric shapes with a ballpoint pen, take pictures of your city or your garden with your smartphone, create a color chart using colored pencils or felt-tip pens, fold a piece of paper, write your name in a stylized way....

3. And there, in five minutes, you have taken a first small creative step. You got started!

Activating your creativity
TO FIND INSPIRATION EVERYWHERE

COURTNEY CERRUTI

Courtney Cerruti works in San Francisco, at Creativebug, an online platform for creative video courses. She practices multiple artistic techniques, including painting and monotype (a limited-edition printing process), and has shared her secrets in three books and numerous workshops. Courtney also has her own store and gallery, Long Weekend, where you can find household objects and art supplies. And finally, with some friends, she organizes drawing evenings, which they call "social sketches." I have always been dazzled by everything that she manages to do, and by her curiosity about the world around her.

What would you say is the best way to go about getting started on a creative adventure?

Being creative and living a creative life is like flipping a switch. It might seem obvious, but you have to make a conscious decision to turn on the switch. Once you've done that, it is hard to go back. It's hard not to see the world through that creative perspective. For some people, it isn't easy; for other people, it is, but they have been discouraged from doing it. I meet a lot of women between forty and sixty at my "social sketch" events who are going back to being creative after their career or their family has stopped being the center of their lives. They understand that this is what they need, that this is what makes them happy. It's too bad not to take advantage of it sooner! At first, I would suggest diving wholeheartedly into what you care about most, or what you think you would be most interested in. Without having tried it out, it's hard to know whether we will enjoy something or not. When I was in college, I thought I wanted to major in anthropology. But after I took a class, I realized that I didn't like it at all! Before you throw yourself into a particular kind of art, try it out, ask questions, explore, get involved as much as you can. Don't just watch, but act. One action will lead to the next, and then on to the next, and that is how you will move ahead.

Your projects are often inspired by small details of daily life, which you collect (challenge 11). Everything seems to be a source of inspiration for you. What tips can you give?

I try to be particularly observant at the very times when I don't feel terribly creative anymore. Then, I make it a point of honor to do the things that I love and that help me to recenter myself and become inspired. For example, I can just go for a walk and pay attention to the details around me: the cracks in the sidewalk, the patterns formed by the bricks of a building, some paint spilled in the street that looks like a work of art, and so on. I can also just enjoy a quiet ten minutes with a cup of tea, putting my phone away, just looking around me. Taking the time to make small adjustments like that can often help you to become more attentive and to develop your sense of observation. This state of consciousness can help you find beauty just about anywhere, to gather inspiration for later, and to become more open in your everyday life.

What does your creative process look like right now?

I don't wait for inspiration to start creating. The most important thing is to sit down and start working, knowing that the first minutes, the first attempts, will not be the best, and might not be good at all. You have to get past this phase in order to move forward. I like to let the creative process guide me. If I'm making

At Creativebug, Courtney assists artists in constructing and filming their lessons, sets up the sets, and gives her own classes. Opposite, one of her sets is pictured along with Charlie, her lifelong companion!

monotypes, I'll let my curiosity take over, and I have a hard time stopping at the end! If I'm painting, the mere fact that I am focusing on creating something that I like pushes me to keep going. I follow what I'm working on until I can't find anything else to change. Sometimes I take a break, so that I am better able to come back to my work with some perspective. Very often, I don't know exactly where I'm going. I'm just curious to see where my material is going to lead me or about trying out new methods. All of these things are very good. In my first book, *Playing with Image Transfers*, I quoted the American psychologist Abraham Maslow, who said that "almost all creativity involves purposeful play." I also think that having fun is an integral part of the creative process. It's important not to neglect that.

What would you say is the way to succeed as an artist?

First of all, staying curious. People downplay the importance of curiosity, saying, "I don't have time for that." But that's what makes life worth living. For me, exploring the things that excite my curiosity is the best way to evolve and to grow as an artist. In order to follow your curiosity, you have to pay attention to what interests you most. And accept the fact that you're going to make mistakes at first. You learn by doing. Plunge into your art 100 percent and give yourself time and space. Maybe you will find that you are good at it, and all the better if so, but push yourself to become immersed in the process, to take the necessary time and perspective, because that's how you really master a technique. I know you might want to plan everything in advance, because the unknown is scary. I remember, when I was a student, how much my friends and I worried! People have often said to me, "What matters is your network." Looking back, I agree. It might be intimidating, but I think it's important, and it shouldn't be superficial. Say hello, participate in conversations, become interested: quite simply, help to animate the community that you would like to be part of. Build on these authentic connections. As you connect with other people, and as you engage more deeply, the pieces of the puzzle will come together.

Instagram : @ccerruti
Site : www.creativebug.com

GETTING READY

The purpose of this section is to help you create an environment that is familiar, reassuring, and conducive to inspiration. The idea is to create a space in two senses: both physical and mental. On the one hand, you will be getting your studio, your office, the place where you are going to practice your art, ready (challenges 5 and 6); at the same time, you will be preparing yourself mentally to be ready to overcome all the difficulties to come (challenges 7 and 8). These challenges will help you to put yourself in the frame of mind of a beginner, to accept your mistakes, and to choose a goal. If you are already well advanced along your creative path and are just experiencing a moment of self-doubt, it's still a good idea to go through this preparation again as though you were starting over. It will help you to see more clearly or to start off into a new direction with a good foundation.

Choosing your ARTISTIC PRACTICE

ARE YOU READY TO GET STARTED BUT ARE NOT SURE WHAT KIND OF ARTISTIC ACTIVITY YOU WANT TO CHOOSE? IS IT A GOOD IDEA TO PRACTICE SEVERAL OF THEM? THIS CHALLENGE WILL ALLOW YOU TO FIND ANSWERS TO THE QUESTIONS THAT YOU HAVE AND DEFINE THE DIRECTION YOU SHOULD TAKE.

Discovery phase

Faced with the plethora of activities available, it can be hard to choose one. If you are able to, I suggest that you try out the practice you are interested in before fully committing. Borrow the materials you need from a friend or take part in a workshop so that you can "feel" the medium and how you respond to it.

How can you tell whether this medium is right for you? Georgia O'Keeffe, the American painter, explained it like this: "I found I could say things with color and shapes that I couldn't say any other way—things I had no words for." Any medium might be the right one for you. Don't go in with your mind already made up. There is no practice that is "just for professionals," "too complicated for you," or, for that matter, "too old-fashioned." For me personally, I was reluctant to get started with watercolors because I thought that the medium had gone out of style. But no medium is out of style, and you do not have to follow any rules. It's up to you to decide what you want to do with it and what approach you want to take!

Most of the time, though, you will already have some idea of which disciplines are attractive to you. Above all, follow your intuition. If you have tried out one kind of practice and felt a connection, didn't notice the time going by, asked a lot of questions, and felt curious about it and inspired, these feelings are all good signs that you should maybe follow your exploration into this practice.

There is no need to keep thinking about it for months: just allow yourself to try it out with a small budget, and then don't be afraid to switch activities if you start to feel that it isn't for you. I'm not saying that you should give up whenever there is the smallest obstacle, but just that if you sense that a path is not right for you, you should feel free to follow another one.

The following questions and comments may also be helpful to you as you make your choice:

◊ Who are your favorite artists? What do you like about their work? What are you intrigued by? What are you obsessed with? It would surely be a good idea to try out their technique.

◊ Which of your senses do you want to mobilize? If you want to work with your hands, pottery or painting might make you happy. If it is images that interest you, have you tried photography?

◊ Are you a collector or a minimalist? Your artistic practice can be adapted to your lifestyle. If you don't want to be overwhelmed by papers and markers, have you thought about digital art? A tablet or a computer could be enough for you to start creating with.

◊ What attracts you to a particular artistic practice? For example, photography, videography, and comic strips are well suited to telling stories. Collaging lends itself perfectly to experimenting with materials. Watercolors are ideal for relaxing while watching colors blend. Art journaling (creating art journals using a variety of techniques to express emotions or recount events) is an excellent way to document daily life. Calligraphy involves very detailed work. And so on.

Whether or not you have a chance to try it out, I recommend that you start by exploring no more than one practice, especially as a self-taught beginner. Mastering a technique takes time and requires concentration. What Bruce Lee said about this was: "I fear not the man who has practiced 10,000 kicks once, but I fear the man who has practiced one kick 10,000 times." Channeling your energy into this one particular practice will allow you to improve quickly. As time goes on, you will develop skills and a style that you can always use later in other mediums as well. But if, on the other hand, you start on three or four different kinds of practice at once, you run the risk of getting discouraged.

Nurturing yourself through other disciplines

Sometimes, however, you might find it essential to try out other mediums or practices. If there is one that you prefer, that doesn't mean that you can't allow yourself to try others. According to the American writer, poet, and painter Daniel A. Miller, practicing several different artistic specialties at the same time allows for artistic cross-pollination. In other words, one practice will nurture the other, and alternating among the various activities will stimulate your curiosity. A second creative activity will often be the ideal solution to allow you to think new thoughts, avoid boredom, or just get out of your comfort zone.

◊ What kind of budget will you need for the discipline you're interested in? Look into whether it matches your constraints. Be aware that most of the time, it is possible to just stick with the basics. For example, photography can become very expensive, but it can also be very accessible: just using a smartphone, you can already learn a lot.

◊ Do you need some specialized equipment for the activity you're excited about? I'm thinking about the use of a press for engraving, or a darkroom for developing photo prints. You should think ahead about these issues as you are choosing your practice.

If you master several different artistic specialties, you're adding more strings to your bow. You can choose the one that suits you best in terms of the message that you are trying to express. This is the approach that many artists take, including the British painter and illustrator Oliver Jeffers, who works in watercolors, oil, and digital art, depending on the project and the target audience (children's books, exhibits, etc.).

Finally, your specialty could be something that is at the intersection of several different practices. In other words, you might combine several mediums to compose your creations, without necessarily being a master of all of them (see, for example, the technique of Deeann Rieves, whose story is on page 116). In order to find out, the only way is to try!

In the long interview that Matisse gave to the critic Pierre Courthion in 1941 (published in *Chatting with Henri Matisse: The Lost 1941 Interview*), the painter said: "I took up sculpture because what interested me in painting was a clarification of my ideas. I changed mediums, I picked up clay to take a rest from painting, in which I had absolutely done everything that I could for the time being. It was done for the purpose of organization, to put order into my feelings and to find a style to suit me. When I found it in sculpture, it helped me in my painting."

The choice of artistic practice is intimately connected with the notion of identity. If, in the long term, you intend to become a professional at your art, then your identity, more than your style, will be your guide. The American author Austin Kleon confirms this in his book *Steal Like an Artist*: "Don't be afraid to go all over the place. What unifies your work is that you are the author." So don't hesitate to experiment with a number of different practices or styles. Over time, your identity will shine through even beyond your productions (for instance, in your communications and your brand image).

Your Turn

1. Make a list of the artistic practices you would like to try.

2. If you're a beginner and you're teaching yourself, I would suggest that you choose one favorite practice to start with. If possible, try it out before committing yourself.

3. If you feel as though it is a combination of techniques that is interesting to you, then, by all means, go in that direction.

Preparing YOUR CREATIVE space

THE CONFIGURATION OF YOUR PHYSICAL SPACE HAS A STRONG INFLUENCE ON YOUR MOOD, YOUR FEELINGS, AND, THUS, YOUR CREATIVITY. THIS CHALLENGE CONSISTS OF PREPARING OR REVIVING YOUR CREATIVE SPACE. THIS WILL CONCRETELY GROUND YOUR PROJECT. IN THIS SPACE, YOU WILL GIVE YOURSELF PERMISSION TO CREATE AND TO BE YOURSELF.

Where should I create?

Above all, your creative space depends on your practice: is it itinerant or stationary? If it involves moving around (as in photography or videography), your creative space might just be a bag packed with your materials. But even if your activity does not depend on moving around (such as writing, design, or illustration), you might prefer the atmosphere of a café to your home. Think about what affects you and what puts you at ease. For example, do you need a light, open space, or do you prefer the opposite, a place that is packed full of clutter and details? Do you prefer a spacious or cozy space? Would you rather be alone or surrounded by people? All of these factors can help you to choose where to be creative.

If you would rather stay home, are you able to dedicate a room or part of a room to your creativity? And if not, what kind of space could you set yourself up in? Have you tried different possibilities? In my case, my creative nook is my dining room table. Don't forget your car if you have one: it can also be a true little creative studio, as is the case for the Québécoise watercolorist Shari Blaukopf.

Yao Cheng's stunning studio in Columbus, Ohio, is white from floor to ceiling, just the way she wanted it. The studio is flooded with natural light and abounds with objects and plants that stimulate her creativity. See her personal story on page 125.

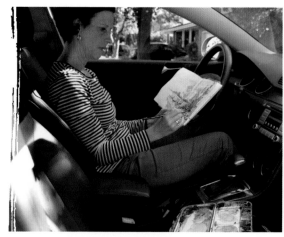

Shari Blaukopf's car is often turned into a little studio, especially during Montreal's cold winters.

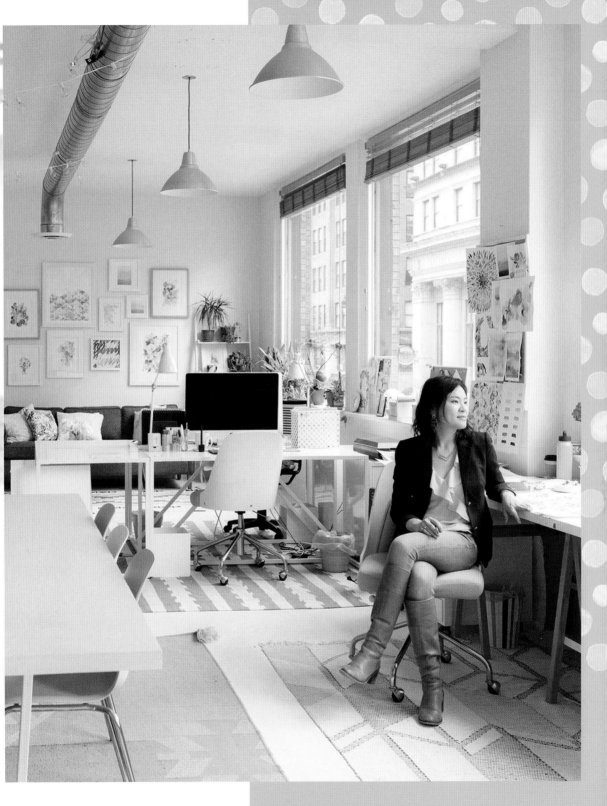

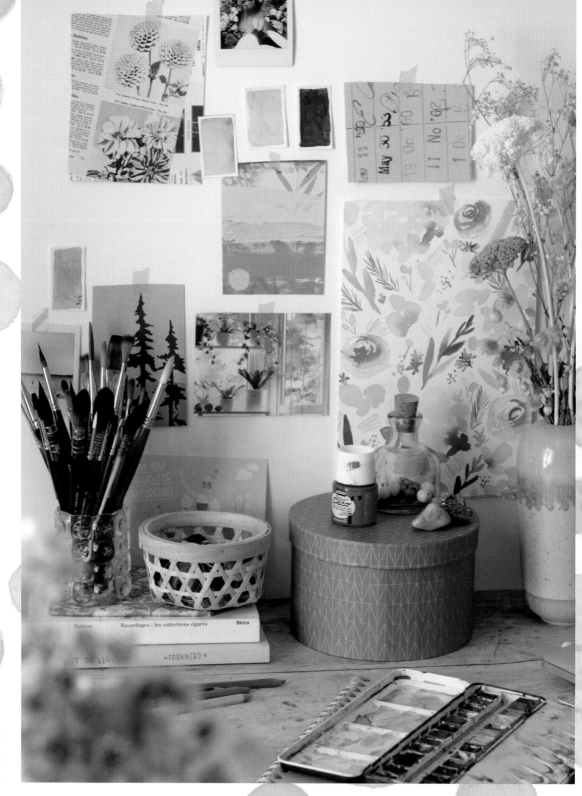

Feel free to change the places where you create. Even if you have your own workshop or studio, it can do you a lot of good to vary your creative environment, especially at times when inspiration is absent.

Preparing a functional environment

The place that you choose should allow you to easily carry out your creative activities. If you don't yet have all the equipment you need, that's OK. Here are some tips for making your creative space functional:

◊ **Art supplies:** What do you need in order to start an art session? Gather the essentials: markers, pencils, pens, brushes, tubes of paint, papers, glue, camera.... And regardless, start with what you already have.

◊ **Electronics:** Do you need electronic equipment? A computer, an internet connection, a headset, a printer, a scanner? Once again, work with what you already have. If you have a fixed creative space, identify your digital and analog areas. Keeping an area that is dedicated entirely to working with your hands will help you to plunge yourself into your creativity more easily.

If you are able to keep a fixed creative space, take advantage of that by decorating it or adding some inspirational objects to make it even more personal.

◊ **Furniture:** What are the essentials for you? A table, a chair, some shelves....

◊ **Storage:** This will be even more important if you have to free up your creative area every day for other uses (for instance, if you use the kitchen table). Keep track of your practice in boxes or folders for reference. Later on, you will be happy to be able to revisit your early work, to see what worked and what didn't. That will help you to evaluate your practice (challenge 20) and get some perspective on your style (challenge 31).

◊ **Light:** This is an essential element for your creative practice. If you can't invest in a lamp, at least get a powerful lightbulb that diffuses white light. It's a very simple step, but it helped me tremendously in being able to paint early in the morning or at night.

Your well-being

Your creative space should not be a source of stress. Atmosphere plays an important role; take the time to work on it. Organizing and decorating (with candles, plants, soft lighting, posters, etc.) is a good way to establish a ritual before a creative session, especially if, like me, you don't have a space that is permanently dedicated to your creativity. Before starting, I pick up my living room and my dining room (where I create), I make myself a cup of tea, I turn on some pretty lights, and I set a plant on my table. This helps me to enter into a creative atmosphere. Many artists have developed ceremonies around the practice of their art. The American painter Flora Bowley, for example, likes to do some stretches, put on music, and light candles to mentally prepare herself for creating.

Concentration

Try to do what you can to encourage concentration when you take a moment to create. If your home allows you to insulate yourself from the hustle and bustle, that is ideal. If that isn't the case, or if you have very little time, at least ask the people who share your space not to disturb you. It isn't easy, but it will help to engage you in the present moment of your creation. What I like to do is to use noise-canceling headphones that insulate me within my creative bubble.

Some of the readers of my blog tell me that they take advantage of part of their lunch break at their workplace as a way to find a calm time and place for creativity. Sometimes, all you have to do is put your phone on airplane mode in order to be able to concentrate. I put mine in another room when I need some calm, so I won't be tempted to check it too often.

Documenting your creative adventure

Use the establishment of your creative space as the time to start a dedicated journal (whether analog or digital). This is where you can keep track of your experiments—small victories and challenges both—and make a note of your moods, take stock, get some perspective. My creative journal consists of a folder on my computer, but also my blog and my newsletter, *Explore!* Continually asking myself where I am in my creative process has definitely helped me to move forward and to go beyond my comfort zone.

Spotlight on Elle Luna

When she was working in the digital sector, the creative space of American painter Elle Luna, appeared to her as follows: "I was sleeping deeply when the sign appeared...in the form of a dream. A room with white walls, with a concrete floor, high ceilings, warehouse windows, and a mattress on the floor." A friend whom she spoke to about her recurring dream suggested that she go find that room in real life. Even though she felt a little silly, she went looking, and eventually found it. Even though there were a dozen other potential renters, she was convinced that she had just found the studio of her dream. A few days later, as she was moving in, she asked herself out loud, "Why am I here?" And, she says, the room replied, "It's time to paint." After ten years in which she hadn't touched a brush, she then started painting again. In her book *The Crossroads of Should and Must: Find and Follow Your Passion*, she explains in detail her feeling that she was at an important turning point.

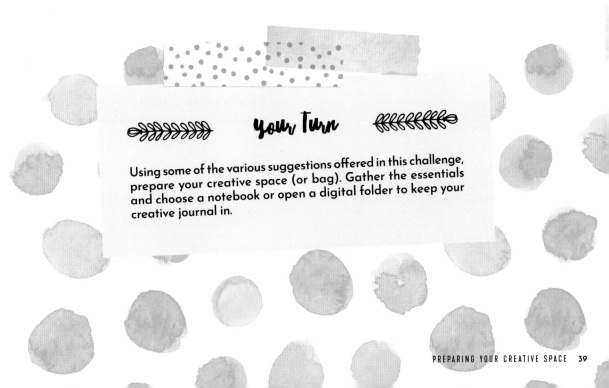

your Turn

Using some of the various suggestions offered in this challenge, prepare your creative space (or bag). Gather the essentials and choose a notebook or open a digital folder to keep your creative journal in.

Accepting your BEGINNER STATUS

YOU KNOW NOW THAT, IN ORDER TO MOVE FORWARD IN YOUR CREATIVE ADVENTURE, YOUR MENTAL SPACE IS AT LEAST AS IMPORTANT AS YOUR ARTISTIC ABILITIES, IF NOT MORE SO. THE WAY YOU LOOK AT FAILURES, IN PARTICULAR, IS KEY. CONQUER YOUR SELF-DOUBTS AND DISAPPOINTMENTS AND GIVE YOURSELF PERMISSION TO BE A BEGINNER IN ORDER TO MAKE YOUR PRACTICE SUSTAINABLE. THIS CHALLENGE WILL HELP YOU DO THAT IN TWO WAYS: BY THINKING ABOUT YOUR ABILITY TO TOLERATE MISTAKES AND BY STARTING NEW NOTEBOOKS.

Being patient with yourself

Giving yourself permission to be a beginner means accepting the mistakes, confusion, and qualms that go along with the first experiments in a creative activity. Being in this state of mind will be very helpful to you, even if you are experienced, but it is not always easy to get there. Your expectations are probably very high because you are comparing yourself with other people. And watch out, because a disappointment early on can unfortunately spell the end of a budding artistic practice.

Accept the fact that everything has to start somewhere. Reaching your creative goal may take six months, a year, or ten years. Prepare your ego to tolerate this waiting period. In a society where everything goes very fast, where everything is just a click away, our egos look for immediate gratification—but the creative process is slow. The best way to overcome difficulties is, therefore, to accept them from the start. Expect failures and accept them, because they are an integral part of every practice. Find satisfaction in the effort that you make rather than in the result. "I didn't do anything worthwhile today" then becomes "I am thrilled that I drew today."

"To achieve success, grow, and be happy, you have to set yourself challenges and then overcome them."
—Alex Mathers, British illustrator and writer

Almost two years of practice in watercolors are in this stack of papers, and a lot of failures. All the better!

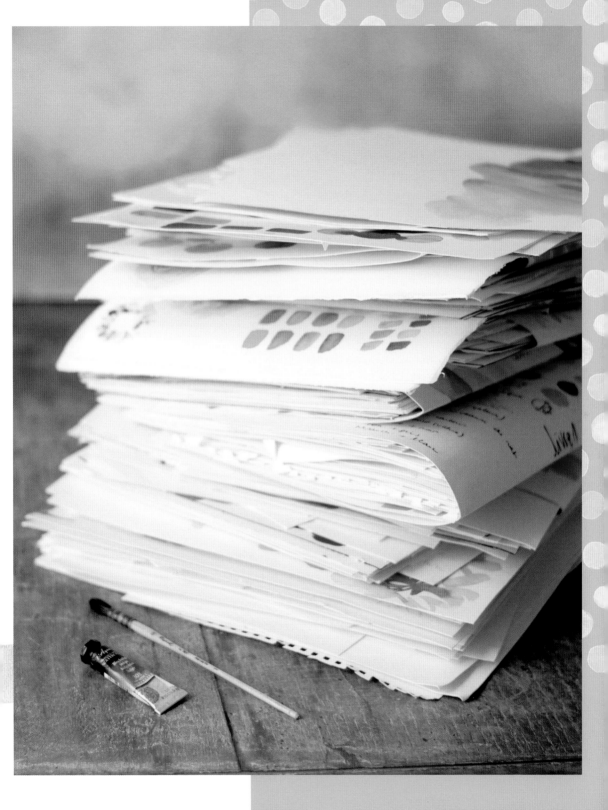

Celebrating mistakes

Mistakes are not just part of the creative process; they are actually helpful to that process.

Noticing that something isn't working allows you to better understand the operation involved, the problem, or the technique. Allow yourself to make mistakes so that you can improve. It is by recognizing your failures, not letting them be too important, and not trying to avoid them at all costs that you will be able to make fewer of them tomorrow.

Matisse, in *Chatting with Henri Matisse: The Lost 1941 Interview* (with Pierre Courthion), explains: "When you're a student, you are focused on only one thing: not making mistakes. That's very bad. You can see mistakes. But it's harder to see the positive things. They are less clear-cut. You don't want to make mistakes...we hold ourselves in check too much. But over time, one makes up for it! At least I have."

Mistakes push us to take risks so that we can try to fix them. They can also be the starting point for a reflection that might finally make you change your mind and come to love a "failure." Thus, a mistake can become a happy accident, the beginning of a project, or an integral part of the development of your artistic identity. Matisse, for example, replaced values with color contrasts. What could have been seen as a mistake when he started out became one of his strengths. Transform your difficulties into opportunities. A mistake can become an asset, if you look at it from the right angle. Atmosphere, personality, colors, movement, contrast, energy: there will always be something missing from your artwork for someone, no matter what kind of art you make. So don't try to please everyone, and don't be so critical of yourself.

Spotlight on Josie Lewis

"Making mistakes is essential for improving your art and watching your style emerge. Taking risks is also necessary in order to have an impact, even a small one, on the world. By taking a lot of risks and making a lot of mistakes, we learn; and finally, failing is not such a big deal. Mistakes do not define us. It's just a piece of information, it does not make us good-for-nothings. We should have a sense of humor about the risks we take in our practice. If something isn't working, we should say to ourselves: 'Oh, that didn't work. What should I do now?'"

See Josie's story on page 93.

Ladder by Josie Lewis,
collage on wood, 76 x 76 cm, 2017

> *"Mistakes are the stepping stones to wisdom. We learn from trial and error; we become wise by understanding problems."*
>
> **—Leon Brown, American baseball player**

Getting beyond fear

There are generally three reasons for trying to avoid making mistakes.

First of all, you might be a perfectionist. If that is the case, then reread the suggestions above so that you can learn to accept mistakes, or read challenge 32 if you are really stuck.

Secondly, you may have so little time to give to your creativity that when you create, you feel like it has to be a success right away. In that case, I would suggest that you balance your technical practice (part 4) with playful phases (challenge 19) as well as experimental ones (challenges 26 and 27). Also read Minnie Small's story, she ran into this same problem (page 150).

And finally, you may be afraid of wasting your materials (paints, paper, canvas, etc.), and you'd rather just keep admiring your collection than touch it.

In each of these cases, I would suggest that you use several inexpensive notebooks that can serve a number of purposes:

◗ **warmup or draft notebook:** to help you relax when you start a creative session.

◗ **test notebook:** to improve your technique, try out new things, make sketches (challenge 23), and experiment (challenge 26).

◗ **final draft notebook**: your "perfect notebook," so to speak. For me, this kind of a notebook represents too much pressure, but it might be right for you, in combination with a warmup notebook.

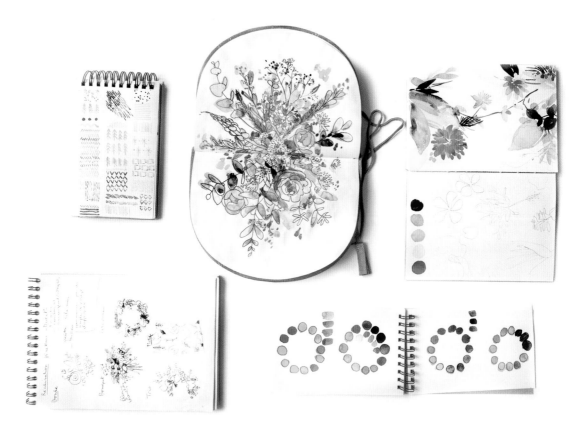

• **idea box (challenge 10):** this can be combined with an observation journal (challenges 11 and 12) and a research notebook (challenge 22).

• **just-for-fun notebook (challenge 19):** not for thinking about the result, but just taking advantage of your art supplies.

You can also just use one notebook that has everything in it: there aren't any rules. Don't be afraid to have disorganized notebooks, and to open them to random pages to avoid overthinking things. If there is a page that you don't like and that is keeping you from continuing to use the notebook, tear it out or cover it up.

"Creativity is allowing yourself to make mistakes. Art is knowing which ones to keep."

—Scott Adams, American cartoonist

Your Turn

In order to help prepare yourself to get better at accepting your mistakes:

1. Take the time for some introspection and think about how you react to mistakes. Is it easy for you to accept them? Do they challenge your perfectionist tendencies and make it hard for you to move forward? Can you give yourself permission to be a beginner? In your creative journal, write down how you feel in response to the question.

2. Even though your schedule might be tight, think about balancing technical practice with more experimental phases (which will also be more likely to produce mistakes). You will find more specifics about how to do that in part 5, "Expressing Yourself."

3. If it is relevant to your discipline, have you thought about using one or more notebooks to overcome your perfectionism? Draw from the suggestions in this challenge to get started in a notebook where you will be allowed to make mistakes.

Don't be afraid of mistakes, and improvise
FOR MORE POWERFUL RESULTS

JORDAN MATTER

Jordan is a photographer from New York. He makes portraits, especially portraits of dancers in natural light. I got to know him through his "10-minute photo challenge" on YouTube, and I was immediately impressed with his ability to improvise. After a career as an actor, he went into photography, which was a field he truly fell in love with and in which he is self-taught. He has now published several books of photography, including Dancers Among Us, a New York Times bestseller, and the 2018 book Born to Dance. He also exhibits his work around the world.

Why did you start a photo challenge on YouTube?

It's an incredible adventure! I wanted to show that in just ten minutes and with a talented dancer, you could easily obtain magical images. I started from practically zero in the summer of 2017, and in less than a year, I had more than a million subscribers. I believe that artists, in general, think too much and try too hard to predict the final result. My grandmother was a painter. She was so afraid of making mistakes that she sometimes spent months just thinking about what shade she should use. I decided to do the opposite, to trust in my instincts. This challenge is sort of an extreme way to believe in your intuition: you have to move, not try to predict. The time constraint allows you to see elements that you would never have noticed otherwise.

Has this challenge changed how you create?

Not really, I've always worked in a rush. I am always on the lookout for the fabulous picture that is just around the next corner. I know that the perfect conditions (light, surroundings, composition) will only come together for just a few seconds, so I dive right in. My photos are not staged. They are all taken spontaneously.

The challenge was intended to show my process, rather than to conceive of it. I have always plunged right in with my work, but I'm happy to see that some people are now following the challenge and have told me that it has changed how they work. What's really great is that they realize that photography does not have to be hours and hours of preparation for one shot. It can be a lot of fun!

What is your best piece of advice for somebody getting started with their creative practice?

Don't be afraid of making mistakes. The problem, I think, is that most people are conditioned by the fear of making a mistake. They come up with an idea, and then right away, they think about all the reasons why it's bound to fail. And so then they go straight on to something else because they've decided that the first idea will never work. Lots of times, when I'm talking to other photographers or to dancers or to anyone else about a new concept that I have, I'll be thinking out loud, and I see the doubt in their eyes. They don't think the project is a good idea. Talking about it helps me to develop my ideas. And so, of course, to start out with, they are not all good. But you have to keep building on these first attempts and not just give up right away! Don't ever throw out an idea too fast under the pretext that, at first glance, it doesn't seem perfect to you!

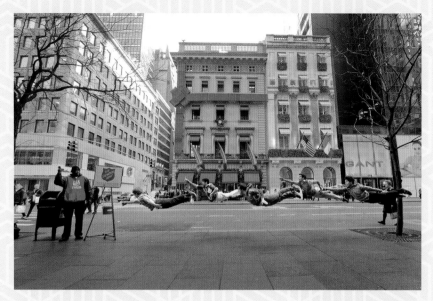

Salvation Army, 2010.

When you think of an idea, that's the first step in the process, not the end. A lot of people who call themselves creative stop their creative process before it has even started. My best advice is to stop getting in your own way and to allow your imagination and creativity to develop freely.

How can we reduce this fear of making mistakes that paralyzes our creative process by keeping us from trying new things?

It's actually simple: you have to fail. Mess up. Over and over again. Every day, a failure. Do you know about "failure therapy"? You literally have to have the goal, every day, of confronting a failure. For instance, going to a restaurant and asking for a free meal. You know that they are going to say no. But keep going. Don't stop at that first no. Even if the final answer is still no, you will have forced yourself to push through to the end, to try everything. If, for a month, you have a failure every day, believe me, at the end of the month, you will no longer be afraid of people saying no to you. You will have already heard it so often that it won't have the same effect on you. Getting beyond this fear of making mistakes is really the most important thing, in my opinion, for developing your creative process.

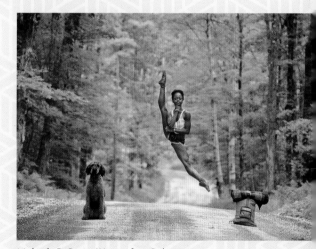

Michaela DePrince, Waiting for a Ride, 2013.

YouTube : Jordan Matter
Site : www.jordanmatter.com

Defining a CREATIVE GOAL

YOU'RE ALMOST READY! BEFORE JUMPING IN, DEFINE AN EFFECTIVE AND CONCRETE CREATIVE GOAL, USING THE MULTIPLE SUGGESTIONS AND METHODS IN THIS CHALLENGE. THIS WILL PROVE ESSENTIAL FOR GUIDING YOU AND HELPING YOU TO KEEP UP YOUR MOTIVATION OVER THE LONG TERM.

What is the purpose of a creative goal?

Moving forward without a goal, as an artist on your own, just letting yourself be carried wherever inspiration takes you, is not easy, especially if you are a self-taught beginner. I believe that defining a creative goal has the following advantages:

◊ **Making your creative project concrete:** If it's written down, it's real. Taking the time to think about your creative dreams and planning your strategy is as important as getting started. Setting this intention makes your project real and helps you to move forward.

◊ **Providing a reassuring framework:** Having a goal simplifies your decision-making process. It's easier to start a creative session if you know what direction you're going. And it will make it easier for you to manage your distractions and doubts.

◊ **Fighting boredom:** This kind of approach will also help you to stay motivated and to feel more enthusiastic. Because you are responding to a challenge, you will avoid inertia and boredom.

◊ **Getting to a higher level:** Having a goal will push you to move to a higher level, because it will be easy to evaluate your progress. When you see everything that you are able to accomplish, you will develop your confidence in your art.

> *"Setting goals is the first step in turning the invisible into the visible."*
> —**Tony Robbins, American personal development coach and writer**

professional goals: these will lead you to build or consolidate your portfolio, sell your products, and exhibit your work.

Which kind of goal best corresponds to your current creative desires? Your choice doesn't have to be final—remember that you can change your goal over time as you evolve.

Defining an effective goal using the SMART method

This method will help you make a simple goal into an effective and motivating objective. The SMART method was first outlined by the American consultant George Doran in the journal *Management Review* in 1981. It became very popular in the professional world, but it can also be applied to your personal and creative life. The idea is to define a goal that has the following characteristics:

S as in specific: the goal should be clear and precise.

M as in measurable: it is easy to measure whether or not the goal has been met.

A as in attributable: who is in charge of making it happen? Since we are talking here about personal goals, I replace "attributable" with "ambitious." When you look at your goal, you should be thinking: "This is ambitious for me."

R as in realistic: the goal should still be realistic. You should be confident in your ability to accomplish the goal.

T as in timely: the goal needs to be achieved within a certain time limit. The idea is not to define a plan of action that is spread out over five years but to think in the shorter term: three to six months, maximum. It's better to give yourself small goals to meet within shorter time periods than an enormous and unmanageable five-year goal.

Different kinds of goals

In his book *The Passionate Photographer*, the American documentary photographer Steve Simon lists different kinds of goals:

project goals: these allow you to complete a personal or professional project.

technical goals: these involve mastering a new skill, gaining expertise in your preferred practice, or taking a class.

material goals: these involve obtaining new materials and mastering their use.

artistic goals: these will push you to research new sources of inspiration (challenge 13), to seek out critiques and feedback, to share and collaborate, to nurture your sensitivity (part 6).

An ambitious but realistic goal means that it is exciting and motivating but not impossible. At first, don't choose as a goal that you're going to be exhibiting three canvases in a major museum a month later. Setting goals that are too ambitious will just frighten you and can lead to procrastination. I urge you to aim high but to stay realistic, given your level and the time frame you have in mind.

As an example, the SMART goals that I gave myself were: to paint one floral watercolor per day for fifteen days and share them on Instagram, to start a video course on watercolor basics within three months, and so on.

Setting one goal at a time thanks to creative sprints

If you're like me, you may have ten different creative goals in mind. I suggest that you only work on one of them at a time. This helped me tremendously to produce higher-quality work and to relieve some of the stress caused by switching between projects too often. Start with the simplest goal. Achieving it quickly will provide you with some essential motivation at the beginning of your creative adventure.

In order to work on one goal at a time, I use a technique that is common in the IT world: agile methodology sprints.

A creative sprint is a two-week period dedicated to one single goal. This is a long enough time period to become immersed in the subject, but short enough that you won't get bored. If the goal is too large for this time frame, I break it down into several different creative sprints. I used this method, for example, to write this book.

But even if your goal meets the criteria of the SMART method, you might still be paralyzed by self-doubts: "It's not even worth starting. It's too complicated. I'll never manage it." Breaking down your goal will help you to visualize the small steps that are necessary for achieving smaller, intermediate victories (which you should still celebrate!). This will also make it easier for you to look forward to your creative sessions. And indeed, thinking ahead about what you want to do is another way to conquer the blank page.

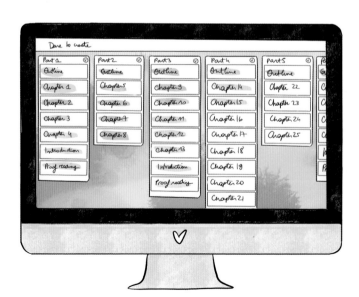

I use the Trello application to organize my creative sprints. This is my Trello chart for the preparation for this book. This helps me to visualize the different tasks, thanks to the card-based format. I can easily allot my cards across fifteen-day periods and follow my progress that way.

Balancing goals with the unexpected

Be flexible with your goals. The ideal is to complete your project so that you can meet your goal, but if something unexpected arises and you feel the need, allow yourself the possibility of letting it go or changing it. Your goal is there to guide you and motivate you, not to keep you from moving forward and evolving.

Also, do not completely block your inspiration with the excuse that it doesn't match your goal. Again, your goal is there to help you stay concentrated and not get distracted, but sometimes it is important to follow an intuition and to take an unexpected detour. The path to your goal will probably not be straight.

Take advantage of everything about the creative process. Enjoy it 100 percent. Don't just focus on the expected result of the goal you have set. With a little more experience and perspective, you will find that you might have less of a need to regularly define very precise goals.

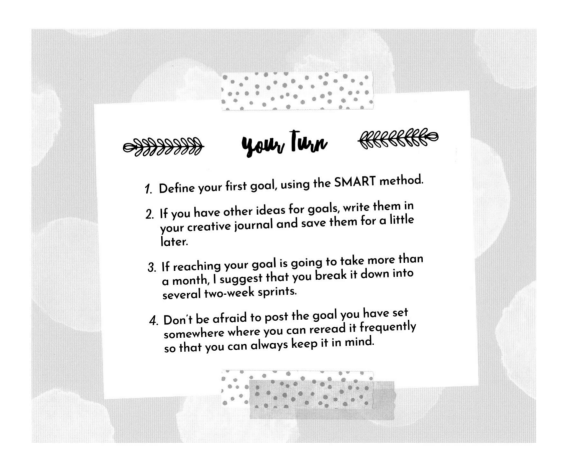

Your Turn

1. Define your first goal, using the SMART method.

2. If you have other ideas for goals, write them in your creative journal and save them for a little later.

3. If reaching your goal is going to take more than a month, I suggest that you break it down into several two-week sprints.

4. Don't be afraid to post the goal you have set somewhere where you can reread it frequently so that you can always keep it in mind.

PART 3

FINDING INSPIRATION

The way that you find and capture inspiration is the foundation for your creative projects. In this section of the book, you will try multiple techniques for developing your curiosity and observational skills and for generating new ideas. As you practice, you will discover which exercises you prefer and add them to your routine. The goal is to become aware of the many possibilities that surround you so that you never need to run out of ideas!

Building your iDEA BOX

THE GOAL OF THIS CHALLENGE IS TO SET UP A SYSTEM FOR STORING AND BRINGING TO LIFE THE IDEAS THAT COME OUT OF YOUR EXPLORATIONS. IN THIS IDEA BOX, YOU WILL COLLECT NOT ONLY WHAT COMES TO YOUR MIND BUT ALSO THE PICTURES YOU TAKE ON INSPIRING OUTINGS, VARIOUS OBJECTS, THE RESULTS OF BRAINSTORMING SESSIONS, AND SO ON. AS SOON AS YOU NEED INSPIRATION, YOU CAN TAKE OUT YOUR BOX AND USE ITS CONTENTS AS A WAY TO PREPARE FOR A NEW PROJECT.

Why collect inspirational ideas?

Inspiration sometimes comes at the most unexpected moments: when you are in the middle of a work meeting or even on the bus. It is easy to forget an idea even if it seems brilliant at the moment it comes to you. In the same way, a trip to a park or to an exhibit, which might be very inspirational in the moment, can become completely forgotten a few days later if you don't have photographs or notes to remind you about it. Collecting every source of inspiration and every idea that you have is a good habit to form. This will allow you to let your mind roam free and then, later, to work on the material that you have gathered.

The format of your idea box

In order to capture your ideas whenever they arrive, and as quickly as possible, choose the idea box format that will work best for you:

◊ **digital:** this could be a memo on your phone, a folder on your computer, or even one of the many applications set up for this very purpose (Keep, Evernote, Trello, Pinterest, Instagram).

◊ **analog:** keep a little notebook and a pen close by; set up a dedicated binder or shoebox.

You can, of course, choose a variety of formats depending on the situation you find yourself in. For example:

◊ **when you are on the move:** the note function on your phone or the little notebook in your bag will do the trick.

◊ **at home:** a shoebox or a binder will be a good place to store papers, photos, and the like.

◊ **on the computer:** use a Pinterest board or Evernote notes.

> *"The artist is a receptacle for emotions that come from all over the place: from the sky, from the earth, from a scrap of paper, from a passing shape, from a spider's web."*
> **—Pablo Picasso**

What should you put in your idea box?

You can put anything in your idea box. Don't wait to be struck by inspiration. Instead, make it a habit to add to your box regularly, with ideas of various contents and formats, without worrying about their quality at first.

The contents could, for example, be connected to:

◊ thoughts or flashes of ideas that run through your mind;

◊ details that crossed your path and caught your attention;

◊ an outing to a museum or a park, a trip, and so on;

◊ information about a subject you are passionate about (challenge 22);

◊ artworks that inspire you (challenge 14);

◊ your own exercises and creative attempts;

◊ a brainstorming session (challenge 13).

The formats will vary depending on the subject:

◊ photos, videos, or pieces of music

◊ notes or audio recordings

◊ sketches or 3D creations

◊ objects

Get into the habit of saving your ideas, even if they are only fleeting visions. The American producer David Lynch, who is also an actor, artist, and musician, compares ideas to fish. In an animated video for *The Atlantic* magazine (*Lynch on Creativity*, 2008), he explains that we can't make up ideas, we can only catch them. He suggests being receptive to inspiration and not judging the ideas that come to you. The goal is to catch as many of them as possible: some of them will be good, and others bad. The best way to know that will be to test them. By being always ready to collect inspiration and to work with what appears, you will capture better and better ideas over time. It will become more and more natural and ever easier.

Should you cull your idea box?

After several months of collecting, your idea box could get a little bit over-full and jumbled. As far as I'm concerned, that's not a problem, because it's better not to discard or forget an idea too soon. I have sometimes used an idea two years after it first came to me. On the other hand, don't hesitate to go through the box on a regular basis. When you've gotten some distance from it, the idea might show itself to have new and different potential. The simple fact of revisiting the ideas might help you to generate new ones. If you want to organize your idea box, I suggest that you sort its elements into three categories: ones with a lot of potential, with a medium amount, and with little potential. This classification system will probably evolve over time. Also, don't forget that an idea is not necessarily something you can use by itself; in challenge 21, you will see how to combine several different ideas.

> "*Your job is to collect good ideas. The more good ideas you collect, the more you can choose from to be influenced by.*"
> —**Austin Kleon, American writer**

Your Turn

1. Choose the format for your idea box (or boxes).

2. In the next five days, collect at least one inspiration every day, without trying to judge whether it's good or bad.

Developing
YOUR CURIOSITY

NOW THAT YOU HAVE YOUR IDEA BOX, IT IS TIME TO DEVELOP YOUR
CURIOSITY ALL THE WAY TO 100 PERCENT! THAT WILL MAKE YOU MORE
RECEPTIVE TO INSPIRATION AND WILL ENLARGE YOUR FIELD OF POSSIBILITIES.
THIS CHALLENGE CONSISTS OF CHOOSING A SUBJECT AND ASKING YOURSELF
AS MUCH ABOUT IT AS YOU CAN, USING THE EXERCISES SUGGESTED HERE. YOU
WILL BE SURPRISED BY HOW MANY CREATIVE PATHS YOU DISCOVER THIS WAY.

Being curious before being inspired

In her book *Big Magic: Creative Living Beyond
Fear*, Elizabeth Gilbert notes that we are not
gripped by passion every day, but that we can
all be curious. How can we exercise our curiosity?
All you have to do is ask yourself questions and
look for information about a topic that excites
your interest:

"How does it work?"

"Where does it come from?"

"Where did it take shape?"

"What does it mean?"

These questions are all paths that will facilitate
the emergence of ideas that may turn into things
that you make. And because curiosity never runs
out, it is an excellent remedy against the problem
of the blank page, and you don't have to worry
about using it in moderation!

*I develop my curiosity using a
subject that I adore: peonies.*

Practical exercises

Complete the following exercises to develop your curiosity.

◊ **Ask yourself about your tastes and interests:** What are the subjects that you're passionate about? Gardening? Vikings? Oceans? It doesn't matter whether it has any relationship to art or creativity. Just learn as much as you can about the subject.

◊ **Ask yourself random questions:** If there is no particular theme that you want to concentrate on, type the first word that comes into your mind into an online search engine, or else open a book up to any old page. That will take you to another subject, another place, or another person. Stop when you have found a subject that tickles your interest and start again, asking yourself questions and collecting information.

◊ **Find out about the work of another artist:** Start the same exercise over again, using the work of an artist that you find attractive. How did that person learn? How did they achieve the effects that you see? Dig further into this analysis using the suggestions in challenge 14.

◊ **Ask yourself questions about the things that you see:** Open your eyes to your surroundings and start finding things out. What surprises you, what intrigues you, what catches your attention? Why do you possess this object? Where did this element in the street come from?

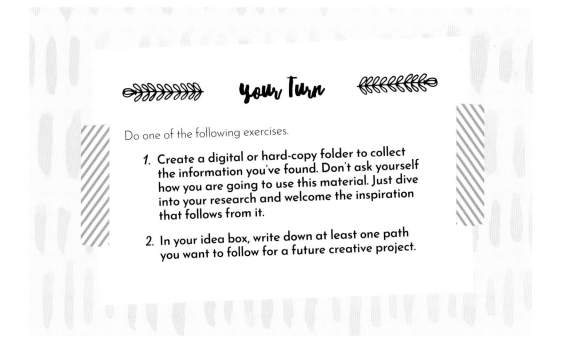

your Turn

Do one of the following exercises.

1. Create a digital or hard-copy folder to collect the information you've found. Don't ask yourself how you are going to use this material. Just dive into your research and welcome the inspiration that follows from it.

2. In your idea box, write down at least one path you want to follow for a future creative project.

Honing your OBSERVATIONAL SKILLS

AFTER HAVING SHARPENED YOUR CURIOSITY, YOU ARE GOING TO DEVELOP YOUR OBSERVATIONAL SKILLS IN ORDER TO CAPTURE UNIQUE DETAILS. THE WAY THAT YOU OBSERVE THINGS IS A TRULY PERSONAL EXPERIENCE THAT IS AN INTEGRAL PART OF THE CREATIVE PROCESS. IN THIS CHALLENGE, YOU WILL BE CONSIDERING A SCENE FROM YOUR DAILY LIFE USING THE NEW TOOLS SUGGESTED HERE AND PULLING OUT THREE INTERESTING DETAILS FROM IT.

Practical exercises

Train yourself to develop your observational skills using the following exercises:

◊ **Pay attention to your surroundings** (whether sights, sounds, smells, etc.): List as many elements as you can in your notebook.

◊ **Using three specific adjectives, describe:** one object or element that caught your attention.

◊ **Break down your surroundings:** into shapes, colors, and lines. This exercise is a way to learn how to simplify. You can try to make a minimalist sketch of this environment.

◊ **Observe the way you would at a museum:** Look attentively at one detail of your surroundings as though it were being exhibited in a museum. What might the artist have been wanting to express with this element?

◊ **Observe with a fresh eye, as if you were on vacation:** Imagine that you are on vacation and that you are discovering these surroundings for the first time. Your apartment is a place that you are just in for the weekend. This exercise will develop your capacity for wonder, recreating the fascination of discovery in a new place.

"Creativity is piercing the mundane to find the marvelous."

—Bill Moyers, American journalist

Courtney Cerruti often embarks on projects based on observation, as you will see in the next two examples.

Spotlight on Courtney Cerruti

#TheColorsof2017 Project

In 2017, Courtney set herself the challenge of observing one color every day, painting it in her notebook in watercolors, and then jotting down a few words about her feelings about the color next to it. These notes are sometimes explicit and sometimes very poetic.

Courtney says that she is "very attracted to colors, to how people perceive them, and to the way that the experience can change how we see the world. For me, some colors are connected to a feeling, a memory, or a story. The #TheColorsof2017 project explores this relationship between color and experience."

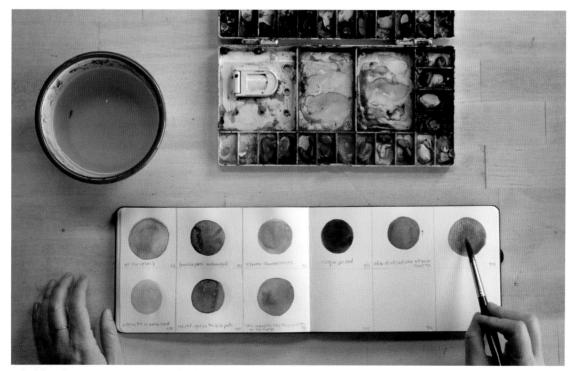

#TheColorsof2017 Project, Courtney's notebook

Examples of notes connected with the colors: "A profound and constant vibration / Hidden from view / Petals, spiced and perfumed / Where the watermelons grow / Why aren't you here?" ...

The #ccmonthofcolor Project

In 2018, Courtney Cerruti worked on a project called #ccmonthofcolor. She explains: "I make one little painting every day of an element that I observed over the course of the day, with the constraint that that there is one color per month. For June, it was green. The format is a calendar, and the result is very visual, very different from the usual organizational setup of a calendar."

See Courtney's story on page 26.

#ccmonthofcolor Project, June 2018.

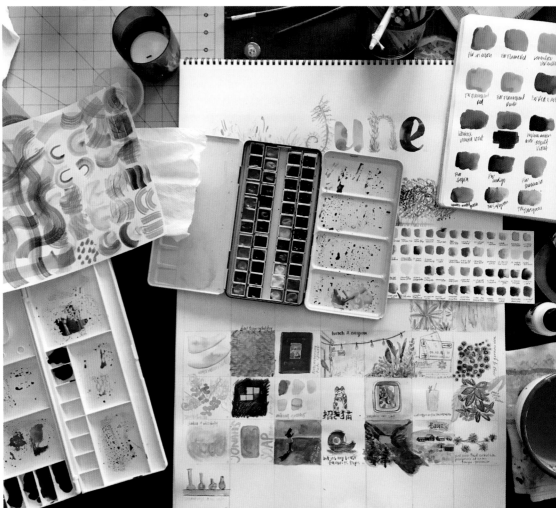

Practicing observation in your daily life

The exercises in this challenge and the previous one will help you become more receptive when inspiration arrives. Remember that any subject can be a source of ideas, especially when you are in a creative lull. Develop your willingness to learn new things daily, not just when you are looking for inspiration. If you practice every day, your vision will open up and have a direct effect on your artistic style.

Get into the habit of recording your observations (notes, photos, videos) in your idea box, precisely and comprehensively. In addition, take notes in your creative journal on how your observational sessions are going: Are they easy for you? Intuitive? Are you having a hard time concentrating? Are you getting bored?

"Go farther than anyone else, that's how you will make progress."

—Austin Kleon, American writer

 your Turn

1. Choose a simple scene from your everyday life: your living room, or a part of your commute to work, for example. Take fifteen minutes and gather as many details as possible, practicing the observational exercises presented in this challenge.

2. Record the three details that you find most interesting in your idea box—they might be something you can use in your next creative project.

Observing and interpreting reality
USING YOUR VISION OF THE WORLD

IRAVILLE

Ira Sluyterman van Langeweyde, known under the name of Iraville, is an illustrator who lives in Munich. Her work combines traditional techniques (watercolors, pencils, and pastels) with digital tools. Her illustrations, inspired by real life, are imbued with softness and poetry. I was very curious to find out how she observes a scene in order to be able to transcribe her vision of the world.

Can you tell us a little bit more about your creative adventure?

"Creative adventure" sums it up well! Today, I am an illustrator and watercolorist, but I started out as a web designer. In college, I wanted to do illustration because I have always loved to draw. But I was intimidated by the other students. I thought that they must all be better than me. I didn't understand, then, that talent isn't everything and that it can be cultivated. Instead of doing the obvious thing, namely starting to draw more so that I could get better, I just completely dropped that career goal and became a web designer. Every now and then, I would create illustrations to enhance the websites that I was designing. It was nothing amazing, sometimes just something based on a photograph.

About seven years ago, when I was working on a client's website, I needed a visual of spreading ink. I got out my art supplies back out, and the magic started working: I watched how the ink spread, and I thought it was amazing. I wanted to draw again, just for myself, something I hadn't done in years. A few days later, I bought paper and some watercolors. It was so much fun, I couldn't stop! Then, I shared my experiences online, and I got very encouraging comments. And that's how I rediscovered my passion. Very soon, I was getting orders from clients. And then it just snowballed, one project after another!

Your paintings tell stories—how do you find the inspiration for your very unique results?

A lot of different things inspire me. Places that I visit, photographs I happen on, even movies or TV series. I am also very inspired by traveling.

Dreaming my world,
watercolor and colored pencil on paper, 2016.

What is your creative process for starting a painting?

I have several different techniques. The first one is to start with a live sketch of a landscape. Another one, that I use when I'm painting animals, for example, involves doing research online to study the animal in question from every angle. I find preparation to be very important, especially when I am working on large projects with a lot of different elements. In that kind of situation, I make a lot of preparatory sketches and then a preliminary drawing that will form the basis of my watercolor. But sometimes I also just don't prepare anything and simply start painting.

I really love the way you transcend reality (shapes, lights, colors) with your own style and your personal vision of the world. How do you go about observing a scene? What advice can you give about this?

Indeed, I don't want to paint in a realistic style because I find it much more fun to make my own interpretations. My illustrations reflect the world as I would like to see it. When I observe a scene, I take my time. I sit down, and I watch quietly. I walk. I take pictures. After I've done my first observational sketch, I often do a second one, less realistic than the first. I change the composition, the shapes, the colors. I have acquired this vision of the world through experience. The advice that I can give is to practice, to train yourself to observe. If you see a courtyard, don't say, "Oh, I've already seen that kind of courtyard...." Look more closely at this particular courtyard, which you have never seen before. Be curious, and don't stay glued to your phone. When you are traveling, look for secret, hidden corners that aren't full of people. Break away from your tour guide and roam the streets according to your own instincts. When you get back home, don't try to make an identical reproduction of the inspiration that you found, but use your imagination.

Van and seagulls, *watercolor and colored pencil on paper*, 2017.

Can you tell us more about your projects in 2018?

In 2018, I published my first book, *Cozy Days—The Art of Iraville*, with 3dtotal Publishing. It shows my best creations but also takes you behind the scenes of my work. For instance, I share tips, a tutorial, and my method for creating my own watercolor pots from pigments.

Sunny roofs, *watercolor and colored pencil on paper*, 2017.

Instagram : @iraville
Site : www.iraville.de

Creating MULTIPLE SOURCES of inspiration

NOW THAT YOUR CURIOSITY AND YOUR OBSERVATIONAL SKILLS HAVE BEEN AWAKENED, I SUGGEST THAT YOU KEEP HARVESTING MORE NEW IDEAS. THE GOAL OF THIS CHALLENGE IS TO DELIBERATELY PLACE YOU IN A STIMULATING SITUATION. TRYING OUT THE FIFTEEN SUGGESTIONS GIVEN HERE WILL HELP YOU TO STAY ENERGIZED AND GET THROUGH TIMES OF LOW CREATIVITY.

Inspiring experiences

Do one or more of the activities described below to provoke your inspiration.

1. Go see an exhibit or visit a museum.
2. Take a walk in the forest or just in the nearest park and take advantage of nature.
3. Read an interview with an artist or watch an artist's video on YouTube (you can find videos showing artists' daily lives in their studios at "studio vlog").
4. Unplug, meditate, relax!
5. Take a trip close by or far from home: roam around a neighborhood in your city, visit a nearby city, go away for a weekend out of state or, if you are able to, go on a grand journey.
6. Get moving. Do some exercise.
7. Change up your daily routine: take a different route to get to work, go to a different grocery store or café, rearrange the objects on your desk.
8. Go to an art supply store.
9. Make a mood board using images that you find in magazines, on Pinterest, or on Instagram.
10. Do some contemplation, daydream, let your mind wander (challenge 28).
11. Do a new creative activity that does not require too much training or supplies (for instance, origami, lettering, doodling, coloring, etc.).
12. Take a course online or in your city.
13. Dive deep into your own memories.
14. Gather up everything you've created and observe your work.
15. Take part in a challenge: you can find a lot of them on Instagram under various hashtags (for instance, start a 100-day creative project with Elle Luna's #The100DaysProject or make an ink drawing every day in October with Jake Parker's #Inktober) or in Facebook groups.

Personally, what renews my creativity the most is going for a walk in a greenhouse, because nature is my main source of inspiration. Here, Copenhagen's botanical greenhouses.

Spotlight on Fran Meneses

In one of her YouTube videos, Fran says: "Motivation and inspiration are like plants. You have to take care of them and not wait until the last minute when the plant is dying to actually take care of [it]. I feel like I neglected my plant for so long because of time or because I've been really busy. Now I have to invest a couple of days or weeks into this thing until I go back on track."

See Fran's story on page 182.

 your Turn

This week, use at least one of the fifteen sources of inspiration listed on the previous page, turning up your observational skills and curiosity to their maximum power in order to find new ideas or just to recharge yourself.

Brainstorming

WHEN YOU WANT TO FIND NEW IDEAS, YOU DON'T ALWAYS HAVE TO GO
OUTSIDE YOURSELF. YOU CAN TAP INTO YOUR OWN SELF BY USING THE
TECHNIQUE OF BRAINSTORMING. THIS EXERCISE INVOLVES GENERATING
A FLOW OF IDEAS WITHIN A DEFINED TIME PERIOD. YOU CAN DO IT BY
YOURSELF OR WITH OTHER PEOPLE, IN WRITING OR ORALLY. AFTER THE
IDEA-GENERATING PHASE, YOU CAN EVALUATE AND SORT THE IDEAS,
CHOOSING THE BEST ONES TO KEEP.

How to brainstorm successfully

Here are some ideas for carrying out a successful brainstorming session.

- **Write it down:** If you are alone, I recommend brainstorming in writing, and preferably on paper rather than digitally. Take several sheets of paper and a pen and write as much as you can. In general, the first ideas will not be the best ones. Work in quantity to produce high-quality ideas (challenge 17).

- **Use a timer:** Set a time limit to create a sense of urgency. The length of time you set will depend on what exercise you are doing, but in general, it should not be more than ten minutes. Of course, if you want to keep going with the exercise beyond that time because you have more ideas to use, then go ahead.

- **Welcome the unusual:** It is essential not to judge. This kind of tolerance will heighten your creativity: dare to express your ideas even if they seem unrealistic or obviously bad.

- **Create an atmosphere:** Make sure you will not be interrupted during the session. Choose an atmosphere that will help you to be creative (challenge 6).

- **Alone or with a group?** The exercises in this challenge are particularly adapted to brainstorming alone. If you would like to find ideas for brainstorming in a group, you can find them online or in books about workplace creativity—see in particular *Gamestorming* by James Macanufo. Try out group brainstorming with your creativity partner (challenge 33).

- **Evaluate your ideas:** After the generation phase, take a step back to get some perspective on the ideas you've produced and choose the subjects or ideas that you find most promising. You can put them in your idea box (challenge 9) and then allow them to evolve (challenge 21).

An illustration of the Post-it exercise. I choose a theme, and I write every idea on a different Post-it. Later, I will rearrange the cards to get some perspective on the subject.

The idea tree

Choose an idea and write it in the middle of your page. Try to explore this theme as far as possible by writing down the ideas and sub-ideas that it evokes for you. Draw connections between the different items that are related: this is a kind of mind map (challenge 2).

Comlumbine Edelweiss

Bell flower

Mountain
flowers tulips

lilies roses

flowers dahlias

Post-its

Choose a theme or a project (for example, a new painting collage, a photo montage, a travel diary, etc.) and write down on Post-it notes what it evokes for you. Rearrange the Post-it notes as you go along, organizing them by theme or by category. This brainstorming exercise is very effective if your subject is vast and includes multiple categories that you cannot easily organize hierarchically.

research copy style

exercices Internet inspiration

I used the Post-it technique to develop the outline for this book. Writing down the ideas in this way allows you to create a spatial organization that gives you a new way of looking at the subject.

FINDING INSPIRATION

The discovery list

This exercise is suggested by the American writer Jim Leonard in his book *Your Fondest Dream*. He suggests that you spend three minutes writing down a list of twenty elements on a particular theme. For a warmup, he suggests choosing a simple subject, like "twenty things that fly." Then keep going with a theme that is more relevant, like twenty subjects to paint, twenty new creative goals, or twenty ways to make progress. Repeat this exercise as often as possible: it doesn't matter if certain ideas keep repeating, but you will also be amazed at how many new ideas you are able to come up with in a short period of time.

your Turn

Use one of the brainstorming exercises suggested here and, from it, pull out three new ideas to put into your idea box.

DEVELOPING YOUR PRACTICE

Now it is time to actually create. Every artistic practice begins with a discovery phase. That's when you learn the technical foundations, drawing on the experience of those who have already mastered them. If you are not yet completely accustomed to your art, you will have to spend time practicing the different aspects of it until they become intuitive. This discovery phase is exciting, but it can sometimes also be discouraging: There is so much to learn! Where should you start? Which subjects should you work on? How should you move forward?

The goal of this section of the book is to help you gain the confidence to take this step. The seven challenges posed here will allow you to gain fluidity and develop useful reflexes. You will break your practice down into individual skills and into small exercises that you invent yourself. In this way, you will take the time to decipher the intricacies of your practice. Forget your fear of mistakes and work in quantity as a way of exercising your creativity, like a muscle.

At the end of this section, take a step back to look at the effectiveness of your practice. Then you will have the confidence to dare to create your own artworks (part 5).

Copying and INFLUENCE

INFLUENCE AND COPYING ARE DELICATE SUBJECTS, THE SOURCE OF
DEBATES AND CREATIVE BLOCKS, ESPECIALLY WHEN THE ARTIST IS
SELF-TAUGHT. IF COPYING IS A NECESSARY PART OF LEARNING, WHERE
IS THE BOUNDARY BETWEEN THAT AND PLAGIARISM? IS THERE A
HEALTHY WAY TO BE INFLUENCED BY THE WORK OF OTHER ARTISTS?
THIS CHALLENGE SUGGESTS A METHOD THAT IS ORGANIZED INTO FOUR
STAGES TO ENSURE A SMOOTH TRANSITION BETWEEN COPYING AND
ESTABLISHING YOUR OWN PERSONAL PRACTICE.

Giving yourself permission to copy

Can you copy in order to learn? I believe that the answer is yes. And it seems to me like a normal process. The greatest musicians began by imitating the creations of their idols. Many painters spent hours in museums copying the works of the masters. Matisse, for example, in his interview with Pierre Courthion (*Chatting*), recounts his experience in Moreau's workshop: "[Moreau] would take us to the Louvre. He had us make copies, under his guidance. He took us to look at the Dutch painters, the Italians." And it's the same way in all fields, artistic or otherwise.

If you are devoting yourself to an artistic practice, you obviously have room for improvement and have something to learn from others. You don't have to reinvent the wheel. There were artists creating before you, and they figured things out, so why not learn from what they have to teach?

Copying has a number of advantages. You can copy in order to:

◊ understand, learn, and improve;

◊ confirm your interest in a particular practice;

◊ develop your curiosity and discover new ideas;

◊ gain confidence;

◊ understand the medium, its history, its culture, and its codes;

◊ avoid the problem of the blank page.

Copying is not a final end, it is just a stage. The purpose of this challenge is to help you to use copying intelligently, and with one condition: don't share this work, keep it for your own reference (see page 76, under "Common-sense advice").

The Method

Follow this four-step method to analyze the work of the people you admire, actively copy it, and then immerse yourself in their style without copying.

Step 1–Identifying your models

Who are your favorite artists? Who are the best ones in your favorite fields? Also go ahead and find out what is going on in other art forms. Ideally, you should follow the work of a multitude of artists with a variety of styles and methods and from many different cultures and time periods. The stories collected in this book reflect the artists who inspire me—they are not all watercolor artists, but nevertheless I learn a lot from them.

Step 2–Analyzing the practice of your favorite artists

After you have identified the artists that you admire the most, try to analyze their techniques and skills. What characterizes each artist? What strikes you about their work? Articulate these feelings, if possible, and identify the particular skills you admire (using just the right amount of water, drawing without a sketch, using subtle color palettes, drawing landscapes, mastering street photography, knowing how to tell a story, using ink . . .). Are there abilities that the artists on your list have in common? What seems to make each of them successful? Which skills seem to be most important for each artist? And conversely, ask yourself what is missing from what you see, and what each artist's weak points are.

Some skills are easy to identify just by looking at your models' final artworks, but others involve the notorious creative process. Do some research to bring these invisible steps to light. These might not even be artistic skills, but rather the ability to collaborate or to be prolific, or even just a way of seeing the world. Collect information: read interviews or books about the artists, go see an exhibit, watch videos, get a look behind the scenes at their daily life via Instagram, a blog, a Facebook group, etcetera. The way that people undertake their practice has an enormous effect on what they produce, and that is what this book is all about. Be proactive: thanks to the internet, you can contact almost anyone on the planet (for good networking, see challenge 33). Why not take advantage of it? Instead of being jealous of your favorite artists, learn from their practice (see Danielle Krysa's story on page 78).

Step 3—Actively Copying

The goal now is to immerse yourself in all these skills by actively copying. Copying is sometimes the only way to understand how an artist arrived at the result they got. Choose a creation to reproduce. Try to deconstruct it at the same time as you are copying. The American writer Austin Kleon, who dedicated an entire book (*Steal Like an Artist*) to influence and copying, suggests: "Don't steal the style, steal the thinking behind the style. What you want is to internalize your heroes' way of looking at the world." In addition, action and movement allow you to immerse yourself in gestures that you can't master by theory alone. Practice does make perfect—or as they say in French, it is by forging that you become a blacksmith.

Now compare your copy to the original. The goal is not to produce a perfect copy—you can interpret the work more or less freely—but to learn something new. What elements could you reuse in your own practice? What do you like the most?

The more influences you have and the more you mix them together (challenge 21), the more you will progress towards your own artistic style (challenge 31).

Step 4—Immersing Yourself in a Style without Copying It

Once you feel a little more comfortable, you can go on to this next exercise, which involves steeping yourself in a style without copying. The goal is not to find your own style, it's a way to understand the techniques of your favorite artists.

Start by choosing one to five works by one artist. Spend about ten minutes observing them carefully, without copying. Notice the details, the colors, the shapes, the similarities. The next day or the day after that, create something from memory based on your observation. This could be something on a subject of your choice, but calling on the artist's style. It could also involve various elements of different artworks that you observed next to each other. Don't worry about finalizing the piece if the result doesn't meet your expectations. The goal is not to make a perfect copy of the works that you chose but to steep yourself in the style to nurture your practice. Then ask yourself: given my result, what did I retain? What stands out? What do I like?

Common-sense advice

The productions that result from the exercises in this challenge (including in step 4) should stay in your private use only. The goal is to practice, not to express yourself (that will be the point of part 5). The suggestions below may be helpful to you.

Authorship of an artwork: adding a filter to a photo or changing the colors of a painting is not enough to make the work your own: it's copying, or even stealing, with the exception of certain cases of appropriation. You will find advice on originality in challenge 21, which has you mix as many influences together as possible (not just from one artist) in order to move further towards your own style.

Distribution: do not include an exact copy of an artwork in your portfolio or on social media. If the copy does not have any personal added value, distributing it, even if you reference the source, will be unwelcome.

Tutorials: this case is an exception; you can share what you created in this case, but you still need to note that it is not your intellectual property. Even if you succeed at the tutorial, note that it is not your own intellectual work. You just need to note that it is "following [Reference Name]." Most of the time, artists will appreciate this attention and will sometimes even share the final products on their own networks.

Commercial aspect: no matter what, do not use the result of a tutorial for a paid project. Likewise, do not sell a reproduction of a painting or any other product derived from a copy.

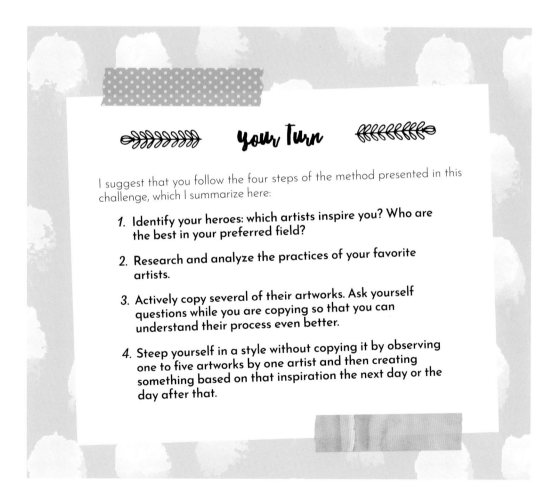

Your Turn

I suggest that you follow the four steps of the method presented in this challenge, which I summarize here:

1. Identify your heroes: which artists inspire you? Who are the best in your preferred field?

2. Research and analyze the practices of your favorite artists.

3. Actively copy several of their artworks. Ask yourself questions while you are copying so that you can understand their process even better.

4. Steep yourself in a style without copying it by observing one to five artworks by one artist and then creating something based on that inspiration the next day or the day after that.

stop comparing yourself
AND EXPRESS YOUR OWN VOICE

DANIELLE KRYSA

Danielle Krysa is an American artist who specializes in collage. She created the site The Jealous Curator, where she has shared the work of other contemporary artists since 2009. She has also written four books on creativity and art, and the most recent one, A Big Important Art Book (Now with Women), which came out in 2018, foregrounds the work and advice of 45 women. What I love about Danielle is her ability to transform a difficulty into a strength.

Dancers, 2018.

Can you tell us a little more about your creative adventure?

I've always loved creating things. But when I was in art school, I couldn't find my place because of the conceptual aspect of the program I was in. So, I switched to a career in graphic design. I didn't do actual art for a long time (and as time went by, I ended up believing I didn't have the talent for it). It was when I was home after the birth of my son that I began to feel the need to create again, but I was discouraged by everything I saw online. I felt like everything had already been done, so what was the point of me getting started? Fortunately, this destructive spiral of self-pity is what led me to start my blog on contemporary art, The Jealous Curator. I felt so much jealousy at that time that I needed to transform it into something positive. I decided to highlight the work of one artist who fascinated me every day on my blog. And fortunately, it went well! Very quickly, my jealousy turned into admiration, and after fifteen years without creating anything, I was excited about creating things again.

You have seen so many artworks in the last few years—what kind of influence has that had on you?

Seeing so many projects has taught me that there is room for each one, and that it's all about being honest with yourself. Create something that is connected to you and reflects your tastes, your personality, your style. I always wanted to make something fun, but in art school, that kind of project was looked down on, so I stopped. By sharing the work of a new artist on my blog every day, for years, I found works that were very serious, but also works that were a lot of fun. I realized that there was room for that kind of thing. I try to use all of this inspiration, in a subtle way. For example, if I see a palette of colors in a sculpture, I might use that in one of my collages. You have to be on guard so that "inspiration" does not become "copying." Once again, you have to find a way to transcribe these inspirations using your own voice.

And what do you think is the way to find your own voice?

Finding your style can sometimes be exhausting, it's not something that happens overnight. You have to give yourself time and space to experiment, you have to produce a lot and keep starting over. Pay attention to the details, places, colors, movies, conversations, etcetera that naturally attract you. I love making lists, so I have a little notebook where I write down everything that captures my attention in my daily life. After a while, you will see certain patterns emerging. For me, it's the color pink, humor, negative space, and good stories . . . and that's what defines my style!

What are your other sources of inspiration?

Random books that I find at flea markets! I love cutting up old books, taking the characters out of context and giving them a new story. That is an infinite source of inspiration.

What are your most recent projects?

At the moment, I am experimenting by using heaps of paint and by increasing the size of my projects. This means working with other media besides paper (because on a large scale, paper curls up and tears), in particular wooden panels. I'm having a grand time!

Car, 2017.

Bradshaw, 2016.

Instagram : @daniellekrysaart
Site : www.thejealouscurator.com

Identifying THE SKILLS that need developing

THE FIRST STEP IN ACQUIRING NEW TECHNICAL ABILITIES IS TO IDENTIFY WHICH SKILLS NEED DEVELOPING AND TO PRACTICE ON SMALL EXERCISES. WHILE IT IS OBVIOUS THAT IN DANCE YOU NEED TO WORK ON YOUR FLEXIBILITY AND BALANCE, AND IN MUSIC YOU NEED TO WORK ON YOUR SCALES, IT IS LESS INTUITIVE WHAT APPROACH TO TAKE FOR PAINTING, FOR EXAMPLE, ESPECIALLY IF YOU ARE TEACHING YOURSELF. THE TENDENCY IS TO WANT TO PRODUCE A FINAL PRODUCT RIGHT AWAY, AND THAT OFTEN MEANS THAT PEOPLE ARE DISAPPOINTED WITH THEIR RESULTS. THIS CHALLENGE ASKS YOU TO IDENTIFY THESE SKILLS THAT NEED WORK AND BE AWARE THAT THE LIST WILL EVOLVE OVER TIME AS YOU MAKE NEW DISCOVERIES. BRAINSTORMING (CHALLENGE 13) WILL ALSO ALLOW YOU TO GENERATE MORE IDEAS.

Initial inventory

Make a list of the skills that you consider to be essential for your practice. Even if you're starting from scratch, make a stab at this. You can either record this list in your creative journal or else keep it on cards where you name the skills. See my research on watercolors, opposite.

Twyla Tharp, the American dancer, choreographer, and writer, undertakes this exercise in her book *The Creative Reflex* and suggests the following list:

◊ athletic skills (coordination, balance, flexibility, endurance, etc.)

◊ theater skills

◊ the ability to work in a group

◊ memory

◊ sense of rhythm

◊ mastery of illusion in order to make everything look easy, etc.

Here I gather some of the basic techniques for watercolor: wet on wet, wet on dry, water-to-paint ratio, and control of one's stroke.

Your goal

Look back at your artistic goal (challenge 8) and compare it with your first list of skills. Is your list missing anything you need to achieve your goal? These might be complementary skills that are not artistic per se (communication, computer, or business skills, for instance).

I would like to be better at digitizing my watercolors, creating patterns, and improving my drawing of peonies.

Your models

In challenge 14, you observed the practice of your favorite artists and undertook a preliminary analysis of their skills. Which of these would you like to develop for yourself? Return to challenge 14 and add those to your list of skills to develop there.

I admire the color palettes, the cityscapes, and the use of negative space in my favorite artists.

Your creative sensitivity

The choice of skills that you want to work on may vary depending on your creative sensitivity. You will see my definition of creative sensitivity in detail in challenge 30. For me, it is a matter of balance, in my projects, between technique, personality, and message.

When you're just getting started, it is often your technical skills that get developed first. Have you also dug into the skills that are connected with your personality or with the message that you would like to communicate?

As for me, I have just started expressing my personality, but I am not yet communicating a message. That might be something that I could work on. If that is a goal for you, you can add that kind of skill to your list.

- ◊ **skills having to do with personality:** self-expression, feelings, interpretation, improvisation, how you approach process, etc.;
- ◊ **skills having to do with your message:** expressing an opinion, sharing your thoughts or questions, telling a story, etc.

I would like to get better at: improvising with acrylics, telling stories with my art, and letting my personality come through more.

your Turn

1. Identify the skills that you would like to get better at using the four exercises in this chapter:

 - essential skills for your artistic practice
 - skills that will allow you to achieve your goal
 - skills that you admire in your favorite artists
 - skills for nurturing your creative sensitivity in one of the three realms of technique, personality and/or message (challenge 30)

2. Write down these skills in your creative journal or on cards.

3. Of the skills you have identified, which do you already possess, whether wholly or in part?

Creating your OWN EXERCISES

YOUR LIST OF SKILLS WILL SERVE AS A FOUNDATION FOR YOU IN CREATING YOUR OWN EXERCISES. IT IS A PLAYFUL WAY TO IMPROVE AND TO START WORKING WITH CONSTRAINTS (CHALLENGE 25). OF COURSE, THE GOAL IS NOT TO BE TOO STRICT WITH YOURSELF. FEEL FREE TO ALTERNATE PHASES OF TECHNICAL PRACTICE WITH EXPERIMENTATION PHASES (CHALLENGES 19, 26, AND 27).

Exercises for practicing a skill

Start with exercises that involve only one skill. In this way, you will be able to master that skill more easily and you will also be able to identify which skills are easiest for you. If a particular project is not working, it can sometimes be hard to figure out why. If there are a lot of different skills involved, and you try to make one element better, it may be that something else won't work anymore. But by isolating skills and practicing one technique at a time, you will have a better understanding of what is causing your difficulties, which will make it easier for you to work on more complete projects later on.

Practicing transparency in watercolor.

Choose a skill and ask yourself: how should I practice it? Make up small, simple, basic exercises. Be creative! For example, see my simple practice exercise on the facing page on the theme of transparency in watercolors. I simply superimpose layers of painting. It's basic, but it helps me to master a technique that seems simple. It helps me to understand better what order to lay down colors in, what I should avoid, and so on.

Variety: Don't keep introducing new exercises. Concentrate on a few exercises that you repeat often. It is, in fact, just when you start to master a skill that it is useful to go even further in your exploration. Below, see my practice on peonies. These flowers are a complicated subject. With this exercise, all I am concentrating on is getting the shape of the peonies in pencil. I will work on colors in a different exercise. Every week, I do a little peony sketch in order to continue familiarizing myself with their complex shape.

Difficulty: Start with small exercises that are easy to evaluate. These are gratifying and will make you want to keep going. And it is easy to slip a few such small exercises into your routine.

Some ideas for exercises: working on light in photography, drawing portraits, mixing colors in gouache, creating texture with pastels.... There are an infinite number of these!

These exercises are an excuse to get you started without being afraid of the blank page. They put you at ease and promote a sense of security that is important for building up your confidence (challenge 4). Feel free to interrupt your practice to follow a path that you find intriguing and to launch into an exploration (challenge 26).

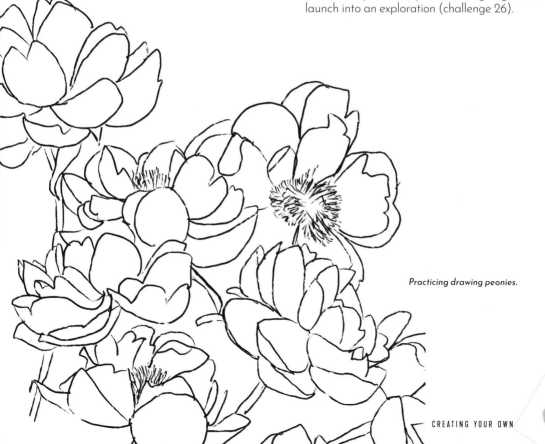

Practicing drawing peonies.

An exercise to practice several skills

As you advance in your mastery of a particular skill, you can then try to combine several at once. See the combination of my work on transparency and on peonies. Having a better understanding of the shape of the flowers thanks to my little sketches, I then also had the confidence to produce the flowers with layers of watercolor, using the transparency technique that I had practiced separately. I would not have had the same result if I had tried to produce this kind of project right away. It was the preliminary exercises that gave me the confidence to move forward. Other ideas for combining techniques: texture + portraits in pastels, light + black and white in photography, contrast + flowers in watercolors.... Once again, the possibilities are endless. Your exercises will become more complex as you advance.

Thus, you will learn to juggle between various techniques ever more intuitively, and you will be able to make better and better use of the array of tools and techniques at your disposal. Of course, as you practice more and more skills, you will be leaving behind drills and moving into the realm of expressing yourself.

Spotlight on Danielle Krysa

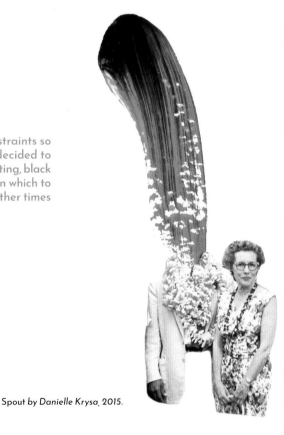

" I create exercises for myself in which I establish constraints so that I will improve in my creativity. For example, I decided to use only black: black-and-white photographs, black painting, black pens, etc. Then, I would give myself only thirty minutes in which to create something. Sometimes the results are magical, other times they are disastrous. But I always learn something."

See Danielle's story on page 78.

Spout by Danielle Krysa, 2015.

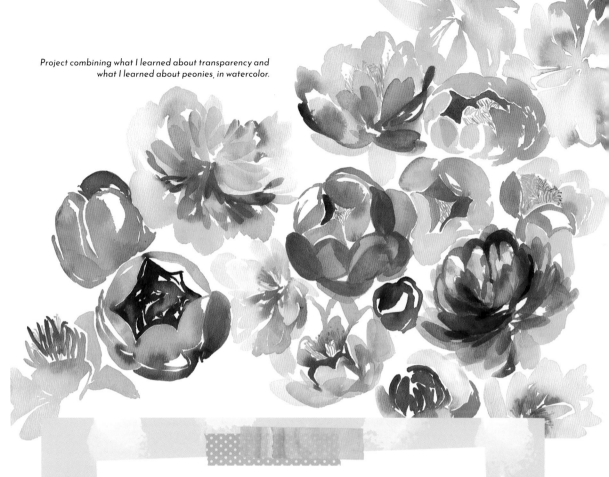

Project combining what I learned about transparency and what I learned about peonies, in watercolor.

 your Turn

Using this challenge as a model, design your own exercises.

1. Choose three skills from your list (challenge 15) and create three little exercises for each one of them.

2. Practice using these different exercises.

3. When you have the feeling that you have a better mastery of the skills that you chose, create and try out a new exercise that combines two of the skills.

focus ON QUANTITY

AT THIS STAGE OF YOUR LEARNING, YOU WILL BE CREATING IN QUANTITY RATHER THAN LOOKING FOR QUALITY. DOES QUANTITY GET IN THE WAY OF QUALITY, OR IS IT, RATHER, WHAT MAKES QUALITY POSSIBLE? THESE FASCINATING QUESTIONS ARE WHAT WE ADDRESS IN THIS CHALLENGE. THE MORE YOU ASK OF YOUR CREATIVITY, THE MORE OF IT YOU WILL HAVE. WORKING IN QUANTITY ENCOURAGES YOU TO LET GO AND DISCONNECT. YOUR MOVEMENTS WILL BE MORE INTUITIVE, AND NEW IDEAS MAY BESIEGE YOU WHILE YOUR HANDS ARE OCCUPIED. WITH THIS CHALLENGE, TRY ONE OF THE THREE SUGGESTED EXERCISES IN ORDER TO PRODUCE AT LEAST FIVE PROJECTS IN ONE CREATIVE SESSION.

Why create in quantity?

An interesting example of the difference between quality and quantity is given in the book *Art & Fear: Observations on the Perils (and Rewards) of Artmaking* by David Boyles and Ted Orland, American photographers and writers. They tell the story of a pottery class in which the teacher separated the students into two groups: one concentrated on the quantity and the other on the quality of their productions. The first group was judged by the pound: they had to produce as many vases as possible in order to get a good grade. In the second group, the students were only allowed to produce one vase, but it had to be the most perfect one possible. At the end of this experiment, the teacher judged that the best vases were the ones produced in the first group. Indeed, by dint of producing vases, the students in the first group learned from their own mistakes and observations and improved their work, unlike the second group, which was concentrating on theory.

Integrating a stage of high-quantity production into your practice can only help you, as this interesting anecdote illustrates. You will make your art better, and you will get faster, be encouraged by all your results, find inspiration more easily, and develop your confidence. On his blog, the British illustrator and writer Alex Mathers puts a number on what quantity means to him: "I'd go so far as saying that you should not expect any traction until you have put out (published, shipped) at least **300 great pieces** of work. This is the kind of quantity to look for, at the very least."

Yao Cheng's watercolor-covered office
(see story on page 125)

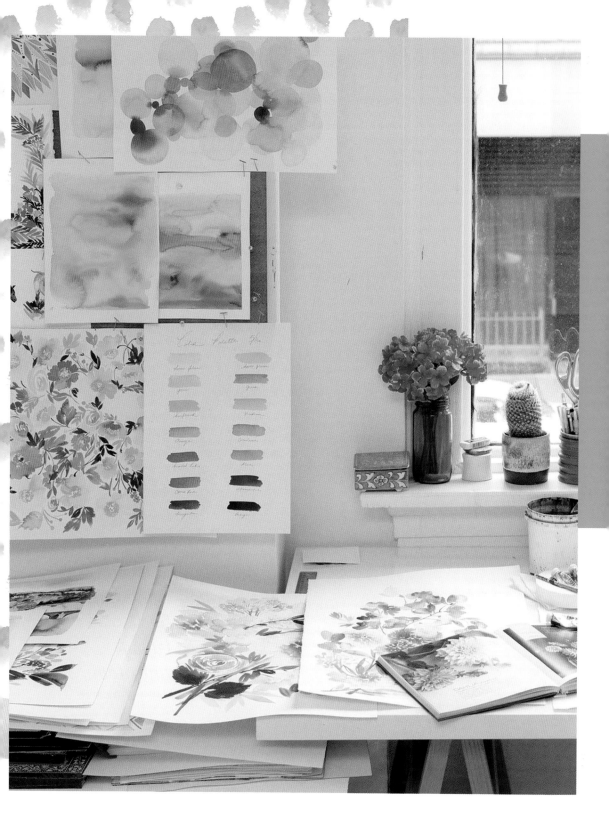

Exercises for creating in quantity

Repeat, vary, constrain: these exercises will help you to create in quantity. You will return to the last two in part 5.

Repeat

Redo an exercise or an exploration for as long as you can feel that there is still progress to be made or as long as you feel curiosity. As in the example of the vases mentioned just above, try to make each attempt better. The fact of repeating will liberate you and give you confidence: the British actress and singer Julie Andrews believes that "perseverance is failing 19 times and succeeding the 20th." You may have heard of the 10,000-hour rule, which was formulated by the Swedish psychologist Anders Ericsson. The idea is that by practicing a discipline for 10,000 hours, you become an expert in it.

However, I should say that I believe that the way that you practice is key, and not just how many hours you spend. Repeating an exercise should not be something that you do just to keep you busy and to give you the feeling of being productive. Redo it if you are learning something new. There is no point in doing something that you have already completely mastered. That does not mean that you should immediately stop an exercise once you have had your first success. Push it a little further in order to understand its subtleties and to have the feeling that something has clicked. Instead of just skimming across the top, the idea is to dig deep into the skills you care about the most and gain expertise in them. Not only that, but repetition is reassuring, because it takes away the pressure involved in new things.

I repeated the same exercise as long as I was learning something new or seeing an element I could improve.

"You don't learn anything from repeating what you know, in effect, so I keep trying to make it uncertain."

—Garry Winogrand, American photographer

Vary

If a subject or a technique is particularly interesting to you, why not create four or five different variations of it? For instance, the photographer Steve Simon explains in his book *The Passionate Photographer* that he made forty photographs of Salem Sue, the largest cow statue in the world (located on top of a hill in New Salem, North Dakota). Having so many variations on the same subject allowed him to work in a multitude of different frames, thus getting stronger photos. In order to push this further, you will work with series in challenge 24.

I returned to the previous exercise, varying it in different color palettes.

Constrain

Repeat one of your favorite exercises with an extra constraint imposed on it. Different formats or just one, various colors, a variety of speeds, a change in tools: the possibilities are infinite. You will work more with constraints in challenge 25.

I returned to the same exercise yet again and added a time constraint. I produced one version in three minutes and one in thirty minutes that was much more detailed.

Working in a small format

Carol Marine, the author of *Daily Painting*, a book about everyday painting, recommends working in a small format: this has a number of advantages for working in quantity. It's easy to finish a piece in less than an hour, which contributes to the creation of a routine (challenge 18). The small format almost completely does away with the fear of not knowing how to finish, and your emotional investment is also much less.

You can also work on several small-scale projects at the same time so that you can alternate between them depending on your mood. Don't think about it too much and follow your feelings to develop your spontaneity. One of your small paintings might give you the inspiration for the next day's project.

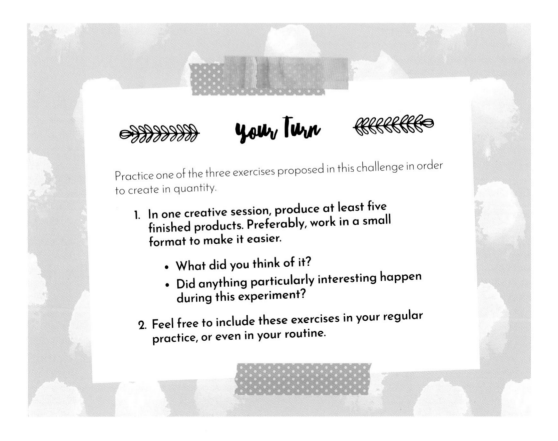

your Turn

Practice one of the three exercises proposed in this challenge in order to create in quantity.

1. In one creative session, produce at least five finished products. Preferably, work in a small format to make it easier.

 - What did you think of it?
 - Did anything particularly interesting happen during this experiment?

2. Feel free to include these exercises in your regular practice, or even in your routine.

Working in quantity
IN ORDER TO GENERATE MORE IDEAS AND PUSH YOUR LIMITS

JOSIE LEWIS

Josie lives in Minnesota. A full-time artist, she uses a multitude of techniques and materials: painting, sculpture, resin, objects, coffee, and so on. She allows herself to be guided by her curiosity and has a very exploratory approach, creating in enormous quantities. I needed to know how she did it! Color is often at the heart of her work, and she published a book on the subject in 2018, The New Color Mixing Companion (Quarry Books).

Can you tell us more about your creative journey?

My father is an artist. I was brought up in the middle of nowhere, in the woods of Minnesota, where the winters are extremely long and snowy. I was home-schooled, and so I did a lot of drawing, piano playing, horseback riding, and I also wrote novels. I never had a problem with a creative block. My biggest problem was choosing ONE artistic practice from all the ones that interested me. After high school, I traveled for ten years and painted local landscapes. Then I went to art school, and I stopped making figurative art. I explored collage, resin, clay, and textiles, and revisited watercolor. That was what really clicked for me.

How do you manage to create so much? It's incredible!

I am prolific because I'm addicted! I love being in my studio. Touching my art supplies and admiring the colors is what releases serotonin in my brain, the happiness hormone...or a magic potion—call it what you like! Being in my workshop, listening to books on tape, I can't think of what could be better. I also like working fast, because that helps me develop my ideas. My projects are often based on repetitive movements and lots of details. I make small adjustments as I go along, or else I completely change methods. That helps me to push my practice towards new expressive spaces. I sometimes consider my art to be a true

Red Solo Cup Blanks, *resin and mixed media, various sizes*, 2016.

scientific experiment, even if I don't know much about the sciences.

Social networks are also a good tool for productivity. If you want to be noticed there, you have to be regular. That means posting something every day, and therefore creating something every day! It's really good practice, a way to establish your routine and dedicate yourself to your art. Of course, social networks also have negative aspects. Sometimes a post becomes popular, and it has nothing to do with its quality or its originality. When I work on large projects, for up to eight hours per day, I don't have anything interesting to post, and that adds pressure. But you still have to remember that it is nevertheless an excellent way to dare to express yourself and create a community.

You work with a lot of different techniques. How do you choose them? Do you keep on working in the older ones or do you constantly have to learn new ones?

I adore arts and crafts stores, but not so much fine art supply stores, which are good for perfecting a "traditional" medium like oil painting. I prefer arts and crafts stores because they are brimming with improbable and unexpected combinations.

I mostly move forward just a little bit at a time, building on what I learn as time goes by. If I have already tried putting salt in my watercolors, for example, then I ask myself: "And why not vodka or olive oil, or silicone?" Most of my ideas don't lead to anything, but that's how you discover new techniques. They say that geniuses don't have one brilliant idea but rather thousands of run-of-the-mill ideas and a few exceptional ones. I'm not saying that I'm a genius, but working in quantity is definitely at the heart of my practice.

Instagram : @josielewisart
Site : www.josielewis.com

Hex Triangle, watercolor on paper, 20 x 25 cm, 2018.

Seed of Life, watercolor on paper, 20 x 25 cm, 2018.

Blue Slither, hand-painted Bristol paper sculpture, 92 x 122 cm, 2017.

Establishing A ROUTINE

IF YOU WANT TO MAKE GOOD PROGRESS IN YOUR ART, THE KEY IS TO ESTABLISH A CREATIVE ROUTINE. UNLIKE A PRACTICE WHERE YOU GO WITH THE FLOW—WHENEVER YOU THINK OF IT OR FEEL THE URGE—A ROUTINE BRINGS REGULARITY TO YOUR CREATIVE MOMENTS AND TRANSFORMS THEM INTO A PRACTICE. CREATING REGULARLY, WHETHER ONCE A WEEK OR ONCE A DAY, REINFORCES YOUR MOTIVATION AND YOUR SKILLS. YOUR PERSEVERANCE WILL BRING YOU CLOSER TO YOUR GOALS AND GENERATE ENTHUSIASM. SETTING UP THIS KIND OF A ROUTINE BY FOLLOWING A MONITORING SYSTEM FOR A MONTH IS THE GOAL OF THIS CHALLENGE

Don't wait for motivation

You have probably used the excuse, "I don't feel motivated today. This is not my day." It's normal. Everybody has done it! But to get past this obstacle, the piece of advice that I have read the most often and on which most artists agree is not to wait for motivation but to just create on a regular basis. What helped me understand this was the dictum: you don't get motivated before you act, but by acting. The solution is to set up a routine: deciding to create every day or every week and then doing it, even if the motivation isn't there. I followed this advice, creating every morning before leaving for work. Sometimes I had to force myself a little, but very quickly, my motivation would come galloping back. If you can't create every day, choose one day of the week: "Every Tuesday, I draw for thirty minutes!"

Setting up a routine reduces your need to make decisions: it means you have to think less and helps you be organized and act. This structure will become familiar to you over time. It will reassure you and help you to calmly move forward towards your goal. Your feeling of resistance will lessen as your routine becomes a habit and...then you won't be able to stop!

> "80% of success is just showing up."
> —Woody Allen

Daily practice of watercolor flowers. In order to help me establish my routine, I created the hashtag #rituelaquarelle (#watercolorritual) on Instagram to encourage other people to practice with me.

Practicing in order to improve

Establishing a routine allows you to set in motion a dynamic of creation. It is better to create once a week for a year than once a day for two weeks. The Chinese philosopher Confucius already said it 2,000 years ago: "It does not matter how slowly you go as long as you do not stop."

In order to get better, you have to practice. It's not a secret. Make your practice into a routine, keep at it, and you will inevitably improve. You will become faster, more confident, more efficient, and less "rusty." It's possible that your creative sessions will be more fruitful. Freed of the endless flow of thoughts about your organization and your to-do list, you will finally be able to concentrate on your art.

Thanks to your routine, you will produce a lot of content that you will then potentially be able to share on social networks. Your work, your persistence, and your seriousness will definitely be noticed. These are qualities that can bring you opportunities.

"We are what we repeatedly do. Excellence, then, is not an act but a habit."

—Will Durant

Creating a habit

Charles Duhigg, an American author and journalist, explains in his book *The Power of Habit: Why We Do What We Do in Life and Business* that "our daily life is made up of habits." According to Duhigg, habits can be broken down into three simple steps: a cue, a behavior, and a reward.

Let us take the example of brushing our teeth: the cue is bedtime, the behavior is brushing, and the reward is the clean, fresh feeling.

◊ **Cue:** This could be a time, a place, an emotional state, the presence of a particular person, or a preceding action. For example: every day after breakfast; coming home from work; every Tuesday at 7 p.m., and so on.

◊ **Behavior:** This is your creative moment (you sit down to paint, draw, etc.).

◊ **Reward:** This could be the creative product itself, sharing it on social networks, the feeling of accomplishment that it gives you, or just the pleasure of taking a shower or having a cup of tea afterwards. It is essential for your routine to generate or be followed by a reward in order for it to turn into a habit.

Charles Duhigg explains that you can't get rid of a bad habit, all you can do is change it by changing the behavior while still keeping the same kind of cue and reward. For instance, if you are in the habit of watching a half-hour TV show every night at around 7 o'clock, why not use that time for creating instead? In just a week or two, the new habit will start to become ingrained.

Spotlight on Courtney Cerruti

"**I** am going to try to continue the project [#ccmonthofcolor] throughout all of 2018, but I'm a realist and I know that it will probably evolve over time. That makes me think of the #100dayproject,* which I find very helpful for establishing a creative routine, staying curious and inspired. But you also have to be able to allow yourself to stop or change a project along the way if it isn't truly useful anymore."

*The #100dayproject has been initiated on Instagram by Elle Luna every year since 2013. The goal is to choose a theme and to publish a creation on that theme every day for 100 days, from April to July.

See Courtney's personal story on page 26 and challenge 11.

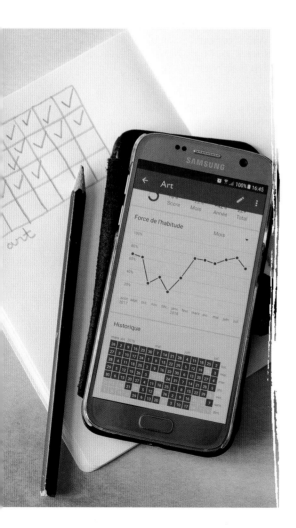

Establishing and keeping a routine may be even more important than having a lot of time."
—Austin Kleon, American writer

Setting up a tracking system

When you establish a new habit, I suggest that you keep a record somewhere of the times when you have your sessions. I use the Habits app (on Android). This kind of app produces an entire range of reports that are intended to motivate you (see the photo opposite). But you can also use your creative journal, your daily planner, or a bullet journal. When you have recorded a number of sessions in a row, you won't want to break your streak, and that will help you to keep going with your routine.

A look at the Habits app, which helps me to keep going in my creative sessions and stay motivated.

 Your Turn

Establish your own routine and try to follow it for a month using the suggestions in this challenge:

1. Decide how often you want to create—if possible, at least thirty minutes per week (challenge 3). Start modestly but try to be regular. Another solution is to start on a radical habit, at least five times a week, but only fifteen minutes at a time, like Pacco (see his story on the next page).

2. Choose your cue: the simplest one is a particular time or after you do a particular thing.

3. Visualize how your routine will unfold. Is everything ready in your creative space (challenge 6)?

4. Make sure that your routine will bring you a tangible reward.

5. Use some kind of record-keeping system (an app or a journal) in order to check off each time that you practice your creative activity over the course of a month.

6. In order to reinforce your commitment, you can explain your plans to someone, or even share a planned routine with several other people (challenge 33).

Beyond creative aptitudes:
GAINING CONFIDENCE THROUGH ROUTINE

PACCO

After a career in communication, Pacco took up cartooning and illustration about ten years ago in order to follow his passion for drawing. In his various collections, he uses humor to take on the themes of family, relationships, and everyday life. In January of 2019, Pacco published the first volume of the uncensored adventures of the Raspberry family, Les Raspberry—La nuit du rituel [The Raspberry Family: Night of the Ritual]. Since early 2017, internet users have been following the daily lives of this joyful, interconnected tribe, who seem to have come straight out of the Stone Age.

In the summer of 2018, you shared a daily fifteen-minute drawing routine on Instagram. Can you tell us more about that?

I admired people who could draw directly without first making a pencil sketch, without erasures. I'm convinced that with practice, everything is possible. If I force myself to try every day, I know that I will improve. So I started a routine: fifteen minutes of drawing without a pencil sketch, every morning (using a timer), and I shared the result on Instagram. It's a good warmup. What I care about the most is educating my mind to avoid being blocked by internal brakes. In the end, the problem is not whether or not you know how to draw but getting past your fears. Routine is a solution that reassures me and allows me to go slowly but surely.

This isn't the first time I've worked with a routine. I've been doing it since I started drawing seriously, more than fourteen years ago. This technique works for me. It works for me to work in short bursts of time, working hard but smart. It gives me the perspective that I need.

One of my most recent routines was set up with the goal of learning how to draw female characters. I had tried everything, but my research took me further from the basic idea: drawing girls! My routine forced me to draw one woman or girl every week and share the drawing on Instagram.

What do you find to be the biggest advantage of a routine?

A routine helps you to gain confidence and to build something that is sustainable over the long term. I did my fifteen-minute morning routine five days a week, every week, from June to August of 2018. That's more than fifty drawings. If I had decided to draw seven days a week, I would have

Illustration by Pacco from his fifteen-minute routine in 2018.

Illustration by Pacco from his women warrior routine, 2018.

ended up quitting because I would have found it too hard. I like reaping the fruits of my work over the long term. It's obvious that the longer you stick with something, the better chances you have of getting where you want to go. Knowing that I can get there gives me confidence. You can apply this same principle to other areas in life, too, like sports.

What was the hardest part of your routine of fifteen minutes of drawing without a pencil sketch?

This project was a challenge to my brain. I was trying to tame it so that it would no longer be my worst enemy! I noticed that there was always a moment of discouragement, about seven minutes into the routine, when I had negative thoughts that tried to keep me from finishing. When I was able to get beyond them and keep drawing, my brain went into another mode. It was no longer a survival mode but a mode of optimization. I said to myself: "I have to go to the end of the fifteen minutes and then post the result on Instagram. I am going to have to manage somehow to do something that is at least presentable."

Once I finished my drawing, I had to post it. For my brain, it is very frightening to show a drawing that is not finished. My brain is never satisfied with what I do. It's not my ally. One of the ways I have found of putting it to sleep is to force it into situations that it finds extremely dangerous and to show it that, in fact, they aren't that dangerous after all. I made a contract with my brain so that it would get used to showing things that it did not think were up to snuff. It got easier and easier, and after just a few months, I got into the habit of showing everything, no matter what it was.

Today I go even further. I'm even more aggressive with my brain: I ask my community to give its opinions about my drawings. I force my brain to recognize that it will not die if it is faced with criticism or the opinions of my readers and viewers. For a long time, it was convinced that if it received anything other than

positive responses, it would die, and yet here we still are, going forward!

What advice would you give for establishing an effective routine?

I would say that a routine is made up of two things: the content and the frequency.

In terms of the content, try to avoid being in the undefined limbo of a beginning. Trying to figure out what to draw can exhaust you. Be very specific. I know that it is more exciting to say, "I am going to learn how to draw" than "I am going to learn how to draw cats." But by choosing a subject, like cats, feet, glasses...whatever it is, that will get you out of that beginning limbo.

The subject also has to be one that motivates you. Try to have fun while you're learning! For example, in my routine on female characters, I was afraid it would be too complicated. So I asked myself, "What would I enjoy?" Drawing female warriors instead of pinup girls, not using color, creating a background with very busy, hypnotic elements—all of these things really energized me.

I had the content. Now I had to figure out the frequency. Can I draw it in just one or two hours? No, that was too restrictive for me. I didn't want to add a time constraint. However, I decided I wanted to do one drawing a week; two would have been too many. I put all of that together, and there you go, I had a routine!

If you're just starting out, make it simple. There is no point in starting from zero and then saying, "I'm going to draw for an hour twice a day for fifteen years." I suggest starting with two to three drawings per week. Even just once a week is great. That comes to fifty-two drawings a year. If you already know how to draw and how to organize your time, then doing five drawings a week is really great, that's what I did (for my fifteen-minute routine). If there was a day when I didn't feel like it, or I just wasn't feeling great, I could catch up on the weekend in order to keep up with my commitment. But if you aim too high, you run the risk of just quitting after two weeks because there is too much pressure, and you will feel guilty about not having met your goal.

And finally, my last piece of advice is not to think too much, but just to act. Your mind anticipates everything. It has prejudices about every process that it's not familiar with, and its expectations will only be negative. So my advice is to go ahead without thinking about it. Just start now!

What do you do to push beyond your limits?

I'm not trying to push beyond my limits at all costs. What I care about is getting a result that I like. I am more in the culture of the result than of the challenge. I don't ask myself the question of my strengths and weaknesses. I ask myself, "What do you want?" If I can do it, great, and if I can't, then I'll try to move forward so that I can get there after all. If I admire what somebody else is doing, I will spend time immersing myself in that person's techniques. Time is a key factor. You really have to take the time to immerse yourself in the process in order to get results. You can't just skim across the top. What counts for me, in the end, is not so much my abilities but my mental state, the confidence that I develop. By establishing a routine, I feel that I can continue to improve in that area, and that is what interests me more than the skill that is ultimately developed.

Instagram : @paccodc
Site : www.pacco.fr

The Raspberry family, at the heart of Pacco's last comic strip project, 2018.

HAVING FUN

YOUR LEARNING PHASE WILL SOMETIMES FEEL DISCOURAGING AND REPETITIVE. NO MATTER WHAT STAGE YOU'RE IN, IN ORDER TO GET THROUGH DIFFICULT PERIODS MORE EASILY, KEEP YOUR CREATIVE FLAME ALIVE BY LOOKING AT YOUR ART AS PLAY. DON'T TAKE YOURSELF TOO SERIOUSLY, AND JUST BE WILLING TO HAVE FUN. THE MORE YOU ENJOY YOUR ACTIVITY, THE MORE YOU WILL WANT TO PRACTICE IT, AND THE MORE YOU WILL STIMULATE YOUR IMAGINATION. THE GOAL OF THIS CHALLENGE IS TO MAKE YOUR PRACTICE MORE FUN BY TRYING ONE OF THE THREE ACTIVITIES SUGGESTED HERE.

Playing

When you are feeling a lull in your creativity, you feel overwhelmed, or you just can't manage to find inspiration anywhere, think of your art as play. Don't have any goal in mind. Express yourself without judgment and without thinking about the end result. Make circles, symbols, mandalas, doodles, dots, graffiti, patterns, close your eyes, and so on. Just put colors on paper and let yourself be guided by what you find fascinating. Surrender to this form of meditation. Reconnect with your sense of childlike joy and put your imagination to work. Just play with your material, according to whatever whim strikes you in the moment, with no particular constraint except for the goal of finding pleasure in creating. Play is a good way to warm up at the beginning of a creative session.

Vary your artistic practices

In order to stimulate your creativity, feel free to change up your modes of expression. Try out different techniques, media, styles, or even a new artistic practice (challenge 5). Give yourself the possibility to change your habits and to remake yourself by following your curiosity. By having fun with these new techniques, you will also be improving your main practice and stimulating your imagination.

"There's nothing easier to lose than playfulness."

—Jim Harrison, American writer

"A little fun can go a long way toward making your work feel more like play. We forget that the imagination-at-play is at the heart of all good work."

—Julia Cameron, American artist, writer, and teacher

Setting yourself a challenge

If you find it boring to try to develop your technical skills, why not work on them in the form of a challenge? This has the advantage of connecting play with a structure (in terms of time, rules, space, etc.). It will give you the chance to experiment without too many expectations for your final result.

For example, the American artist, illustrator, and writer Lisa Congdon proposes a simple challenge in Danielle Krysa's book *Creative Block: Get Unstuck, Discover New Ideas*. Congdon's idea is that you should choose a theme or an object to paint every day for thirty days in a different way (changing up media, colors, angles, etc.).

You will also find different ways to push yourself through play in challenge 29.

Your Turn

Try one of the following practices in order to make your learning process more fun.

1. Just play.

2. Try out a new technique or artistic practice.

3. Transform one or several of your exercises into a challenge: 30-day challenge, 100-day challenge, 365-day challenge, 10-minute exercise, 3 exercises in an hour... The possibilities are endless!

Evaluating YOUR PRACTICE

WITH THIS FOURTH PART, YOU HAVE BEGUN YOUR CREATIVE PRACTICE BY WORKING ON THE TECHNICAL BASICS. AT THIS STAGE, IT ISN'T EASY TO EVALUATE WHETHER OR NOT YOU HAVE IMPROVED, AND THAT CAN BE DISCOURAGING (CHALLENGE 32). IN THIS CHALLENGE, YOU WILL FIND THE ADVICE YOU NEED IN ORDER TO GET SOME PERSPECTIVE ON YOUR LEARNING PROCESS AND DETERMINE THE BEST EXERCISES FOR YOU BY WAY OF THREE QUESTIONS. LOOKING AT YOUR PRACTICE WITH A CRITICAL EYE IS AN IMPORTANT STEP THAT WILL INCREASE YOUR MOTIVATION AND PUSH YOUR ART IN THE DIRECTION OF GREATER EXPRESSION (PART 5).

Do you like this exercise?

Your artistic practice, particularly when you are at the stage of technical exercises, should not feel like torture. Follow your curiosity and your tastes: what techniques do you find intriguing? What do you enjoy the most? What makes you happy? Follow the directions that these lead you in. Your learning process is a way for you to gain confidence and gradually make you want to express yourself (part 5). If you like what you're doing, you won't even notice the passage of time and you will be able to tolerate mistakes and failures much more easily. Don't force yourself to do things that you don't like; otherwise, you may get bored and lose your motivation.

Is this exercise easy or hard?

Putting aside the question of the result (whether or not you think it is a success), was the exercise easy or hard to finish? I would suggest that you lean towards small, easy exercises. There is no point in forcing yourself to tackle large, impossible tasks: that's ambitious, but daunting. Break a hard exercise down into small steps, or build up to the difficulty a little bit at a time. For example, if you want to learn how to paint a landscape, start by practicing painting clouds, rocks, and water effects separately, then put them all together at the end (challenge 16). This will allow you to have a series of small successes, which will stimulate your progress. If you break things down this way, then after a few practice sessions, you will be totally able to succeed at exercises that seemed too hard when you started.

Does this exercise use your strengths or your weaknesses?

The difficulty of the exercise and how hard it is for you to manage it are two different things. Try to be objective about your strengths and weaknesses. Then you will be able to ask yourself: should I be working on my strengths or on my weaknesses?

◊ **Working on your strengths:** If you are at the beginning of your practice, in a phase of discovery, make a point of using and working with your strengths. For me personally, one of my strengths is painting watercolor flowers. At the beginning of my practice, I decided to concentrate entirely on this subject instead of going in a lot of different directions. But people kept telling me, "Paint something else for once!" I concentrated on my

strength and, building up my confidence, was able to quickly learn a whole set of techniques that I now use for other subjects as well. Marcus Buckingham, the British writer and motivational speaker, says: "If you only work on your weaknesses, that will pull you down and, at the very best, result in small improvements. Instead, you should think of your weaknesses as what they are, things that weaken you, and find ways to work around them."

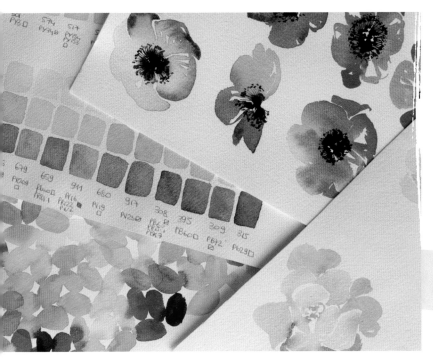

Some of my favorite watercolor exercises, which I have worked on a lot: peonies, anemones, creating color charts to study water proportions, color fusion, and finding harmonious palettes.

Some other examples of exercises that matched the criteria of this challenge for me when I was trying to get better at transparency and depth in watercolor painting.

◊ Working on your weaknesses: Later, once you feel comfortable with the technical basics, come back to your weaknesses. For instance, my weaknesses in watercolor painting are landscapes, people, and architecture. Now that I have a better foundation, I do try to work on these areas, and I learn a lot from that. If exploring your weaknesses interests and intrigues you, then working on them will take you out of your comfort zone (see Fran Meneses's personal story on page 182).

"I am always doing that which I cannot do, in order that I may learn how to do it."

—Picasso

Good practices

In summary, your practice should concentrate on exercises that combine:

🔹 **fun:** if you're not having fun, you will lose your motivation over the long term;

🔹 **an acceptable level of difficulty:** it is better to do small, quick exercises that are easier to repeat and that don't use up all of your energy;

🔹 **learning about and using your strengths:** at least in the discovery phase of your artistic practice;

🔹 **repetition:** as long as you are still learning something from the exercise.

As in many parts of life, twenty percent of the exercises will be responsible for eighty percent of your results (corresponding to the principle of the French-Italian economist and sociologist Pareto, who has stated that 80 percent of effects are due to 20 percent of causes). Therefore, you should concentrate on the part of your learning process that creates the most value. I do not recommend, at this stage, asking for a critique of your work or an evaluation of your strengths and weaknesses. A negative opinion could heavily damage your confidence (challenge 35). Instead, use your own introspection and remember that there is no one right answer.

 your Turn

Make a complete evaluation of your creative practice, using your creative journal and the following questions.

1. List the most recent exercises and experiments that you've done.
2. What did you like the least? What was hardest for you? Which exercises did not use your strengths? Which were too repetitive? Eliminate these exercises from your practice.
3. Review the list of the skills that you want to develop (challenge 15). Are you seeing progress in these skills? Do you want to work on something new? If so, think about what new exercises you should try out.
4. Review your organizational systems (routines, goals, schedule, etc.). Can you optimize them, or adapt them so that you can create more easily?
5. Do you feel like your skill base is solid enough for now? Why not start working on projects that are more complete and more personal? If that is the case, then it is now time to move on to part 5.

PART 5

EXPRESSING YOURSELF

After having tried out a lot of different exercises in order to feel more comfortable with your art, it is now time to try some projects that are more finished and more personal. In this part, I offer you a few different approaches: more methodical and guided (challenges 21 to 24) or more spontaneous and intuitive (challenges 25 to 27). Try out both kinds, and you will find yourself naturally more at ease with one or the other. The important thing is to immerse yourself in the different challenges in order to finish projects. By creating a variety of contents, you will be able to identify the methods that work the best for you and gradually move closer to your own identity.

Combining IDEAS

HOW CAN YOU BE ORIGINAL? THIS CHALLENGE ADDRESSES THIS SENSITIVE SUBJECT AND PROVIDES A SIMPLE SOLUTION: COMBINING IDEAS. THE WAY THAT YOU COMBINE THE DIFFERENT KINDS OF INSPIRATION THAT YOU GATHER IN YOUR DAILY LIFE IS UNIQUE TO YOU. THE FOUR EXERCISES OFFERED HERE WILL ALLOW YOU TO GAIN CONFIDENCE AND LEARN HOW TO MAKE ORIGINAL COMBINATIONS. THERE IS NO SUCH THING AS A BAD IDEA, SO TAKE ADVANTAGE OF THIS CHALLENGE IN ORDER TO EXPERIMENT!

Unique vision and originality

"Is my art truly original?" Every artist has asked themself this question. Here is the answer that works best for me: nothing is truly original. According to the French writer André Gide, in his "Treatise on Narcissus," "everything has been said before, but since nobody listens we have to keep going back and beginning all over again." The fact that a subject has been dealt with before is not a reason for you not to interpret it in your own way; everyone has their own unique vision of the world. Don't try to be original but try instead to be curious, and to express yourself authentically. Your eye will develop as a function of your sources of inspiration, tastes, models, inspirations, experiments, research, technical skills, experience, and so on. Once you have collected all of this content in your idea box (challenge 9), you can mix it up and combine it in order to shape your own expressive voice. The more varied your initial material, the more unique your combinations will be. These will then serve as the basis of your creations.

◐ Spend some time observing and experimenting, and then mix up these influences rather than trying to create something brand-new. Just make what you yourself would like to see, read, or hear.

◐ If you aren't sure whether your creations are truly personal or not, look at them and ask yourself: "Is this undeniably me?"

Answer as objectively as possible: is other people's work predominantly present in your creations, or as a positive influence on you? At the beginning, it is perfectly normal to see the stamp of other people's work more strongly than your own in what you create. But don't be discouraged. Keep on observing and practicing (parts 3 and 4). You will see that as time goes on, your own combinations will become more and more unique.

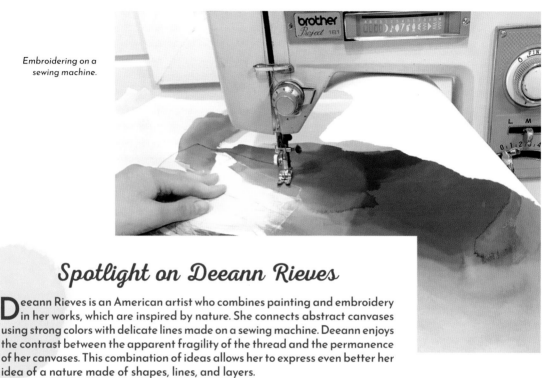

Embroidering on a sewing machine.

Spotlight on Deeann Rieves

Deeann Rieves is an American artist who combines painting and embroidery in her works, which are inspired by nature. She connects abstract canvases using strong colors with delicate lines made on a sewing machine. Deeann enjoys the contrast between the apparent fragility of the thread and the permanence of her canvases. This combination of ideas allows her to express even better her idea of a nature made of shapes, lines, and layers.

See Deeann's story on page 116.

> "Some writers confuse authenticity, which they ought always to aim at, with originality, which they should never bother about."
>
> —W. H. Auden, British poet, writer, and critic

Make your ideas bear fruit

Your idea box is full, and you are ready to take advantage of its contents. How should you go about creating unique combinations of ideas? These four exercises will help you do that. Your first attempts may not be the best, but keep at it.

Connect: Analyze your collection and look for elements that have something in common (their subject matter, their shape, etc.). Gather them together to create a new idea. The connections may be more or less subtle. When you analyze your box, don't get rid of any ideas. They may come in handy later. Sometimes ideas need time to incubate. Sometimes they will stay in your idea box for several years, until the day when they reveal their potential (challenge 28).

Combine: Take two or three different inspirations and combine them. Keep at it and believe in yourself. As you practice, you will find yourself prouder and prouder of your combinations. Observe how Deeann Rieves (story on page 116) combines ideas.

> "Creativity comes from a conflict of ideas."
> —Donatella Versace, Italian designer

Ø Transform: Start with one of the ideas from your box and transform it in order to end up with a new idea. Can you put it in a new context? Change its parameters or its colors? Simplify it as far as it can go?

Ø Develop: Choose an idea and immerse yourself in its subject matter, doing research (challenge 22) or brainstorming (challenge 13). Add elements to the initial idea.

 your Turn

1. Take stock of the materials you have gathered in your idea box. Are you satisfied with what it contains: sources of inspiration, influences, tastes, observations, ideas, experiments, research, technical skills, earlier creations? Go back through parts 3 and 4 of this book and the challenges offered there to develop this material further if you aren't quite satisfied with it.

2. Use the four exercises offered in this challenge (connect, combine, transform, develop) in order to develop three unique combinations of ideas.

3. Then you can use these combinations as the basis for a creation (challenge 23) or a series (challenge 24).

Combining your tastes
IN ORDER TO CREATE UNIQUE TECHNIQUES

DEEANN RIEVES

Deeann is a multimedia artist based in Nashville, Tennessee. She combines several different techniques in her work: acrylics, pencil, chalk, but especially machine embroidery and collage. The results are stunning! Deeann's subjects are mainly abstract, and her activity focuses on orders for paintings, recently in large sizes. She also offers a variety of collections through her online store.

How did you first get the idea to combine embroidery and painting?

In art school, I took several textile design classes, and I loved working by hand with fabrics, thread, and embroidery techniques. In my painting classes, I did more traditional paintings, but what I really enjoyed were collage and the effects of texture. After I graduated, I worked on a figurative series for several years, and the backgrounds were more abstract, created from collages. I realized that I preferred the abstract backgrounds to the figurative foregrounds, so I decided to try an abstract series. I had never really worked on abstraction in art school, aside from my little samples of textile design. Strangely, I felt more comfortable creating abstractly with thread and fabric. So I followed that trail and worked on a textile series. But I missed painting.

When I'm stuck, I like to try things out on paper to see what direction I should take my work in. One day, when I was doing that exercise, I realized that I could do machine embroidery directly on paper that I had already painted on, thus combining my two favorite techniques.

Can you tell us more about this process?

I sew onto pieces of torn paper and then I glue the paper onto wood panels. I keep adding layers of painting and texture as I go along. A lot of people ask me why I paint on wood panels instead of on canvases, and I tell them that it's just my personal preference. I find that it works better with my process and with my collage work.

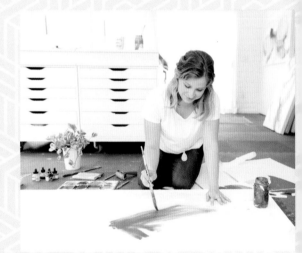

Painting in progress.

What advice would you give to a beginner who is trying to combine ideas or techniques?

It's important to try to work in different media: canvas, wood, watercolor paper, tracing paper—to see which of them work the best with your process. Experiment as much as you can with different media and colors and concentrate on the process, with little series of studies where you aren't putting too much pressure on the result. I have drawers filled with "test" paintings that I won't show to anyone but that are important because they allowed me to get to where

I am today. The only way to get to interesting combinations is to invest time and work.

What do you to develop as an artist?

I try to change my habits a little whenever I have the chance. That does me good. I change my subject matter, my format (very large or then just the opposite, very small), the base (wood, paper), and so on. In the fall of 2017, I started creating a series of abstract landscapes, and at the beginning of 2018, I created a black-and-white series that combined abstraction and nudes. Trying to use my current style for more figurative subjects had a positive influence on my work. That's why I think it's important to push yourself out of your comfort zone and test your limits every now and then. In any event, what you spend your time on will influence your work one way or another.

Sewing on paper.

Instagram : @deeannrives
SIte : www.deeannrieves.com

The unique result of Deeann's combination of ideas.
See also challenge 24.

Making a
RESEARCH BOARD

THE IDEAS THAT YOU'VE COLLECTED AND COMBINED IN THE PREVIOUS CHALLENGES ARE PROMISING, AND YOU ARE ABLE TO START MAKING SOMETHING DIRECTLY USING ONE OF THEM AS A STARTING POINT. FOR A RESULT THAT IS EVEN MORE FINISHED AND PERSONAL, I SUGGEST THAT YOU PUT TOGETHER A RESEARCH BOARD. NO MATTER WHAT YOUR ARTISTIC DISCIPLINE, THE IDEA IS TO PULL TOGETHER DOCUMENTATION AND EXPLORATIONS ON THE SUBJECT OF YOUR CHOICE ON ONE OR MORE LARGE SHEETS OF PAPER. THUS, YOU WILL CONSTRUCT A VERITABLE REFLECTION, WHICH WILL MAKE YOUR CREATIVE PRODUCTION EVEN MORE PERSONAL AND PROFOUND.

What is a research board?

Unlike an inspiration board, a research board goes beyond just a collection of images. This is a true working document, mostly made up of things you have made yourself, which will help you become more familiar with your subject.

It's up to you to choose the format that works best for you. As for me, I prefer to work on large sheets of paper, either a tabloid size (11 x 17 inches) or even larger (the European A2 size, 16.5 x 23.4 inches). But you can also pull your research together in a notebook, a folder, or on a wall. Even if your art is not something that is usually transcribed onto paper (such as a photo or video project, for example), this written research phase will be useful. You don't have to know how to draw. You just have to give yourself the chance to dive into your concept. You will gain confidence, develop your vision, and add complexity to your artistic production.

How to proceed

Starting point

The basis of your research could be a theme, an idea, or a combination of ideas.

A photo of the water lilies in Paris's Jardin des Plantes was the basis for the following research session.

Documentation phase

Explore your subject as extensively as possible (using the internet, books, references, interviews, videos, etc.). Use your curiosity to study it in all its aspects. Take notes, make sketches, collect images and texts, straight onto your research board. Don't focus on trying to make your board look pretty. It just needs to be useful, to allow you to create connections and stimulate new ideas. Use multiple boards if you need more space.

Exploration phase

Now that you are more deeply acquainted with your subject, it is time to create something using all of this material. On some new boards, explore a lot of different graphic possibilities based on your subject (challenge 26). Look at this phase like a problem-solving exercise, where you need to find something interesting to use in a creative production. Use the broadest range of media possible, even if they aren't your specialty: ink, storyboarding, watercolors, pencil, pen, collages, photos, digital images, and so on. Don't be afraid of making mistakes.

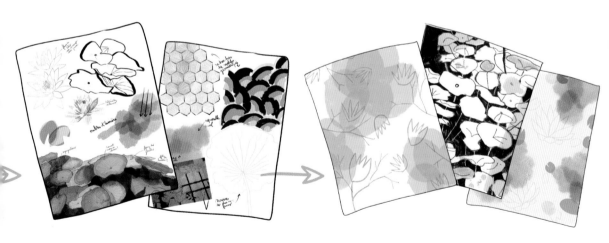

I collected a large number of images of water lilies so that I could study them from every angle. I made sketches of the flowers, the leaves, and I took notes on the colors, the light, and so on.

I tried several different solutions based on my research. These are only drafts, and I mixed several different techniques (digital images, watercolors, paper, etc.). This gave me the inspiration for ideas for motifs.

Waiting by Fran Meneses, 2016.

Spotlight on Fran Meneses

"**M**y creative process evolved a lot over the years. When I started, I didn't do very much research. A few sketches and then I was done with what I was making. But now, my projects are more complicated (or I make them more complex). I think about the characters, the concept, for weeks or even months. In 2018, for example, I was working on my 2019 calendar. I could have said, well, after all, it's only a calendar. But I always want to do everything as well as possible, I try to understand what people like, how I can differentiate myself, etc. And after pulling together all of this research, I try new things. I allow myself time to experiment and to dig, and that has really pushed my creative process to evolve."

See Fran's story on page 182.

Your Turn

Create your research board: spend at least two or three hours on it over several weeks.

1. **Choose a base for your research board:** I prefer a large-size sheet of paper, tabloid (11 x 17) or even larger, but a regular letter-size sheet, a notebook, a binder, or a wall where you can paste up your research are also all good solutions.

2. **Choose a theme for your research.**

3. **Gather as much documentation on your subject as you can, from as many different sources as possible.**

4. **Using the material you have collected, experiment until you reach the beginnings of a creative project. Use at least three different mediums.**

STARTING OVER

YOU CAN USE YOUR COMBINATIONS OF IDEAS AND YOUR RESEARCH WORK IN A FINISHED PRODUCT. IT MIGHT REQUIRE SEVERAL PREPARATORY STUDIES BEFORE YOU HAVE A FINAL VERSION. IT IS THIS PROCESS, MADE UP OF TRIALS AND SELF-CORRECTIONS, THAT I SUGGEST YOU TRY IN THIS CHALLENGE.

Preparatory studies

The masters of painting often made studies, that is to say, preparatory paintings, allowing them to understand their subject better (in terms of colors, composition, etc.) and to arrive, after multiple trials, at their finished product. According to Picasso (in his *Propos sur l'art*, Gallimard), "You don't make paintings, you make studies, you're always just getting closer." Or as Gustave Courbet said, in an article by Gino Severini, "One should be able to start a masterpiece over again at least once, just to make sure that one wasn't being fooled by one's nerves or chance." Matisse, in his interview with Pierre Courthion (*Chatting*, 1941), makes it clear: "People often add, they superimpose, they complete, without even touching the underlying design. But as for me, I redo my design every time. I never get tired. I always start over, basing myself on whatever my previous state was." Starting a project over in order to develop it further and make it better is the whole point of this challenge.

> *"I think that all artists, if they are honest with themselves, have to believe that the best part of their oeuvre, and in fact of their life, is ahead of them."*
>
> —Jan Saudek, Czech photographer

Preparatory studies and self-corrections for a floral painting.

Iterative process

It took me a long time to understand that this kind of preparation, which felt laborious to me, can be a daily practice. When I started working in watercolor, I had a very hard time imitating my favorite artists, and it was discouraging. When I looked more closely, however, I realized that their creations were often the result of two, three, five, ten attempts, each one better than the ones before. It wasn't enough to try to copy the tenth version: I, too, had to develop my own creative process. Working by feeling my way forward, trial by trial, reassured me. On the one hand, I was liberated from the pressure of wanting to succeed on the first try, and, on the other hand, by repeating the same movements over and over, I let go and gained in confidence. It is now your turn to try this iterative method to create confidently. Maybe, like Minnie Small (personal story on page 150), it won't suit you at all, but you won't know unless you try! Read Yao Chang's story on the facing page as well.

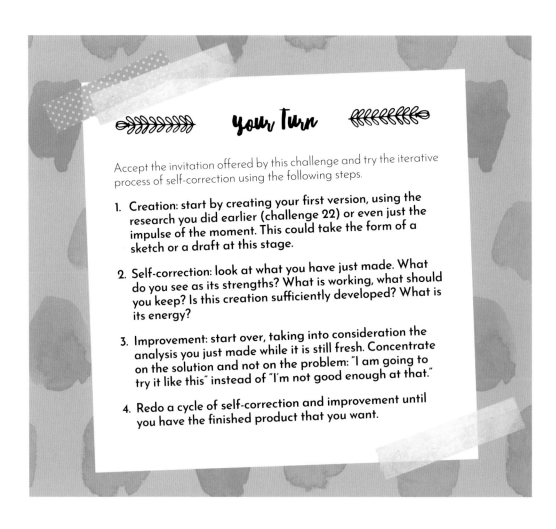

your Turn

Accept the invitation offered by this challenge and try the iterative process of self-correction using the following steps.

1. **Creation:** start by creating your first version, using the research you did earlier (challenge 22) or even just the impulse of the moment. This could take the form of a sketch or a draft at this stage.

2. **Self-correction:** look at what you have just made. What do you see as its strengths? What is working, what should you keep? Is this creation sufficiently developed? What is its energy?

3. **Improvement:** start over, taking into consideration the analysis you just made while it is still fresh. Concentrate on the solution and not on the problem: "I am going to try it like this" instead of "I'm not good enough at that."

4. **Redo** a cycle of self-correction and improvement until you have the finished product that you want.

Starting a creation over
UNTIL IT ACHIEVES VISUAL AND VISCERAL BALANCE

YAO CHENG

Yao lives in Ohio. After going to art school, she worked at Abercrombie & Fitch, where she discovered watercolors. Three years later, she started her own business based on this medium, offering posters, linens, stationery, and artistic licensing. Before I realized that Yao often worked using the iterative process, I had tried to reproduce her paintings, because I used her courses to learn how to paint in watercolor. But I was destined for failure because she herself had started her paintings over and over several times. This was one of my first lessons in the importance of the creative process.

Can you explain the different steps of your creative process to us?

In general, I start with an idea or a memory. It might seem vague, but that's what I then start researching. Sometimes, I visualize shapes connected with these inspirations. But at any rate, I go straight to painting. I don't necessarily make pencil sketches. I consider my first painted attempts to be sketches. I paint three or four versions of the same idea before I am satisfied. At this stage, anything is possible, I let my intuition guide me, and I don't take these steps too seriously. I don't put pressure on myself or expect it to be perfect. If it isn't, I start over. That's all!

Creating in watercolors is fast. I just need a few hours or days to finish a project. I like that a lot, because I tend to have lots and lots of ideas in mind that are just waiting for me to try them out. I often have three or four projects going on at the same time, and I alternate among them. Every creation is like a conversation. There is a lot of improvisation. Some element might give me a new piece of information that I have to respond to. A particular color might let me know what color I need to continue with in order to find a balance. My approach to watercolor is very much oriented towards the creative process. I love it when the pigments and the water interact when everything isn't quite dry yet. The result is just the imprint of the process. I prefer the process to the result—that is I prefer to live this exploration.

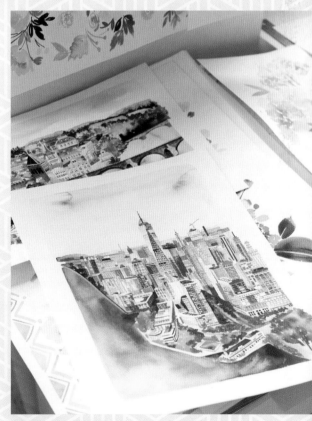

Capturing her source of inspiration in a few brushstrokes is Yao's challenge. This spontaneous exploration is more interesting to her than the final result.

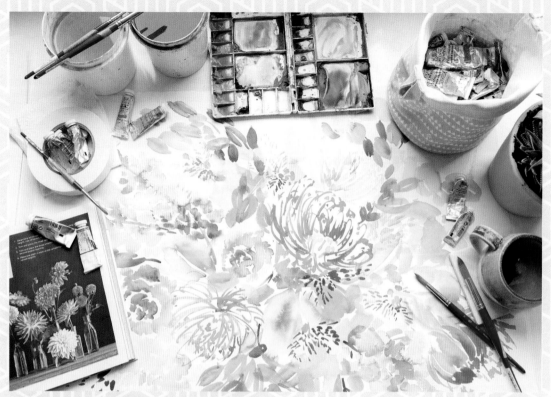

Research and first tests.

What makes you feel like you need to redo a painting?

I always try to find a visual and visceral balance. Visual balance, for me, is heavily tied to colors, to the way in which I work with the warm, cold, and neutral tones. I know I have achieved a visceral balance if I manage to capture the feeling that I had in mind at the beginning, when I started making the piece. It's hard to explain. I remember an exercise I used to do in art school: drawing blind for thirty seconds. It's an exercise in which you have to quickly grasp what is in front of you, with one continuous line, without looking at the paper. It seems impossible, but it forces you to immediately identify what you want to say with your drawing. That snapshot of my vision is the visceral balance that I am looking for. Does this painting accurately convey the idea or fleeting memory that I had when I began it?

When do you know that a painting is finished?

Most of the time, it's truly instinct. My work is really based on intuition, and I try to follow my instinct from the beginning to the end. Sometimes it's hard, and of course, there are some paintings that I have worked on too long! And yet, even when I have gone too far, I start over with a new version. The fear of not knowing when to stop is intimidating. If you feel an urgency to push your creation farther, then go for it. The worst that can happen is that you will start over again with a new version, which will definitely be better!

Instagram : @yaochengdesign
Site : www.yaochengdesign.com

Creating A SERIES

ALL OF THE RESEARCH AND THE PREPARATORY WORK THAT YOU DID IN CHALLENGE 22 WILL CONVERGE TOWARDS ONE OR MORE FINAL CREATIONS. IF YOU CHOOSE TO MAKE JUST ONE, THEN IT WILL BE THE SOLE AND COMPLETE REFLECTION OF ALL OF YOUR DELIBERATION (CHALLENGE 23). A SERIES, ON THE OTHER HAND, "REINFORCES THE IMPOSSIBILITY OF MASTERY. EVERY INDIVIDUAL WORK, A FRAGMENT OF A HYPOTHETICAL WHOLE THAT IS EXPLODED AND FOREVER LOST, REFERS TO ALL THE OTHER MEMBERS OF THE SAME SERIES" (DENYS RIOUT, *QU'EST-CE QUE L'ART MODERNE? [WHAT IS MODERN ART?]*). IN THIS CHALLENGE, I OFFER YOU THE POSSIBILITY OF EXPLORING THIS SECOND OPTION.

What is a series?

Many artists have used this exercise. It is generally accepted that the person who began it was Claude Monet, in 1877, with his versions of *La Gare Saint-Lazare* at different times of day. Some twenty years later, Eugène Atget gave up painting to embrace documentary photography of "old Paris," which was then changing fast. He photographed parks, streets, Parisian interiors, and decorative details, all in the form of series.

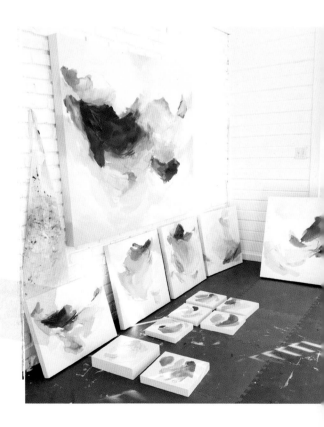

Deeann Rieves works in series a lot, as in this collection in her studio. See her story on page 116.

A series, then, is a set of creations that work together and share the same idea or documentation as their starting point. The series does not necessarily have an order in which it should be read or in which it was created. *The Blue Nude IV* of Matisse's famous series, for instance, was begun first and finished last.

If you're particularly interested in creating a series, why not transform it into a challenge? That way, it can help you establish your routine (challenge 18) and make your project more fun (challenge 19). The American painter Elle Luna made the 100-day challenge famous (challenge 12); she has taken it on every year since 2013 and shares it with her followers.

your Turn

Your turn to create a series!

1. Choose a central theme—for instance, what came out of your research phase (challenge 22).

2. Explore the various facets of the theme with a variety of creations that speak to each other: five drawings, twenty paintings, or forty photos. Unlike with repetition (challenge 17), these creations are more finished and less technical. They can work either together or separately.

Using CONSTRAINTS

IN THE FIRST FOUR CHALLENGES IN THIS PART OF THE BOOK, YOU HAVE SEEN HOW, USING YOUR IDEA BOX AND RESEARCH BOARDS, YOU CAN DEVELOP FINISHED PRODUCTIONS. WHEN YOU TAKE UP THIS CHALLENGE, YOU WILL BE CREATING A PIECE USING CONSTRAINTS. CONSTRAINTS SERVE AS A CREATIVE MOTOR, AS CHARLES BAUDELAIRE SAID ABOUT THE SONNET: "BECAUSE THE FORM IS CONSTRAINING, THE IDEA SPRINGS OUT MORE INTENSE!"

The purpose of constraint

Many artists, paralyzed by too many opportunities and too much choice, suffer from the blank-page syndrome. What to do? Where to start? If you don't feel like diving into research or doing trials and studies in order to prepare your work, using constraints can be a good solution. In literature, one of the most famous examples is Georges Perec's book *The Disappearance* (1969), which does not have the letter e in it anywhere.

More generally, couldn't we say that an artistic movement consists of a group of people who create under the same self-imposed constraints? Limits will guide and inspire you. They will transform the act of creation into a problem-solving exercise. Feel free to let them evolve or even to let go of them if they are no longer serving your creativity.

Constraints can be of all different orders and can involve, for example, time, subject, style, format, budget, purpose, as well as technique, process, collaboration, distribution....

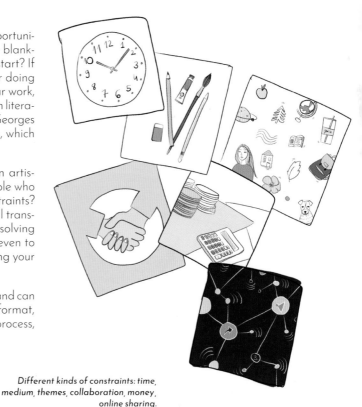

Different kinds of constraints: time, medium, themes, collaboration, money, online sharing.

Using your limits

You may already be imposing constraints on yourself, such as not allowing yourself to work with your weaknesses—for instance, by saying, "I will never understand perspective!" Your environment may also be a limit (for instance, a lack of space to create in). Why not try to use these constraints and make them into your inspiration? That's what Phil Hansen, an American multimedia artist, did. In his 2013 TED talk, he explains that when he was in art school, he had a condition that suddenly caused his hand to shake uncontrollably, making it impossible for him to work in the pointillist style he had been using. In despair, he stopped creating. But one day he decided to use the shaking in his creative practice, working on a large scale so that his shaking would not be detectable. Since then, he has worked heavily with constraints in several series, including *Goodbye Art*, twenty-three pieces intended to be destroyed.

> "We first have to put limits on ourselves so that we won't have any. What I thought would be the ultimate limitation turned out to be the ultimate liberation."
>
> **—Phil Hansen, American multimedia artist**

Playing with constraints

In order to work quickly and easily with constraints, some artists write them down on cards. The deck of cards *Oblique Strategies: Over One Hundred Worthwhile Dilemmas*, created in 1975 by the musician and producer Brian Eno and his painter friend Peter Schmidt, is, without a doubt, the most famous example. These cards feature advice, quotations, and challenges. The cards can be used to start a creative session or to unblock one. You can pick one card and follow the advice it gives, or pick several and let yourself be inspired by the combination that they offer.

You can easily find the list of oblique strategies online.

> *"Art is born from constraint, lives through struggle and dies through liberty."*
> —André Gide

The French musician PV Nova also uses constraints in his creative process and shares his experiences through videos on his YouTube channel. His first large-scale project using constraints was *10 Days/10 Songs* in 2017. For ten days, he created a complete piece every day, respecting ten constraints (tempo, instrument, style, keyword, technique, etc.). His small team also produced a documentary, as well as a record cover for each daily piece. In 2018, PV and a larger team tried the adventure again, this time with *11 Days*. See PV Nova's story on page 132.

your Turn

Now it's your turn to create a series!

1. Just like Brian Eno and Peter Schmidt, or PV Nova, create your own constraint cards. Use the suggestions in the challenge to choose your constraints, and write them on your cards.

2. Pick three of the cards.

3. Create something using these constraints, and let the ideas come to you.

Taking control of constraints

IN ORDER TO MORE EASILY FREE YOURSELF OF THEM

PV NOVA

PV Nova is a musical Swiss Army knife, simultaneously a musician, singer, actor, comedian, and hitmaker. A member of the successful group Les Franglaises, he also shares his projects and experiences on YouTube. His recent challenges 10 Days/10 Songs (2017) and 11 Days (2018) immerse us in his creative process and his work with constraints. The albums were recorded in ten and eleven days, respectively. Every day, his online followers could find a new song, a documentary on his creative process, an illustration, and, in 2018, a choreography. The constraints were chosen at random every day live on social networks. In the summer of 2019, PV went on tour with the Internet Orchestra, a group that was founded on YouTube.

You use constraints in a number of your projects. Can you tell us why?

It was a pretty long and winding path that caused me to adopt the principles of creation by constraints. My reflection began when I was a teenager, I had seen a documentary on the work of Georges Perec, a friend of Raymond Queneau, and together they had formed the group Oulipo, *L'ouvroir de littérature potentielle* ["Workshop of potential literature"; Author's Note: this was a group formed in the 1960s around the concept of literature using constraints. Its members defined themselves as "rats who will build the labyrinth from which they will try to escape"]. Perec is an apostle of constraint, one of the people who has worked with it the most, especially with his best-known book *La Disparition* (*The Disappearance*), which excludes the letter "e." The documentary that I saw was about another one of his books, *La vie mode d'emploi* (*Life: A User's Manual*), which he wrote using a huge number of constraints and which has left many doors open to speculation to this day; people try to guess what the constraints were. It was fascinating to enter into this man's mind. I thought it was brilliant, especially because there is such a playful aspect—of course, constraints are funny, and they help you avoid the blank page—and also because, more generally, it is a reflection on the profession of creator. It is interesting because, at any rate, everyone is dealing with constraints all the time, whether it involves the media in which one is going to create, the tools one has available, the method of distribution, or any other number of things. These are constraints that we are subject to most of the time, whether we take them on on purpose or not, whether we are conscious of them or not. At any rate, these are constraints we are subject to, not constraints we choose. What is interesting is to turn the problem around and to define all of these constraints in order to liberate yourself from the negative understanding of the idea of constraints. Establishing a framework of constraints means freedom more than anything else, and it's very stimulating. I wanted to apply that to my work, and so I thought about the YouTube medium, how to use it wisely. I thought about composition and all the factors involved in it, and I decided to do an experiment for myself, but also to share it with my audience. Beyond the final result, I find it interesting to be able to see the entire journey, which can then inspire others to toward a creative vocation as well.

Given your experience now, what have you learned about this kind of creation using constraints? What sort of things should people try to avoid or to embrace?

It's hard to say what you should avoid or what you should embrace. I think everybody needs to experiment to draw their own conclusions. Giving advice is

how much I might move away from my constraints, they are always there. When I compose at the piano or on the guitar, because I happen to have them in front of me at the moment or because I just feel like it, without thinking, I'm using a constraint. Composing at the piano is not the same thing as on the guitar. It seems obvious, but constraints like that are always present. I'm also thinking about the constraint of time, because you rarely compose a piece that is twelve minutes long. You're also subject to the listening habits of your viewers or listeners. And finally, you never compose from scratch. You use the tools that you have at hand to express an idea with—which can also be another constraint, the message that you want to convey—and you compose for people and for methods of distribution. I really don't believe that there is any kind of creation that does not involve constraints. And so, might as well have fun with them if we can't get around them.

Do you use other techniques to stimulate your creativity?

My creativity is fed by everything that I experience. Of course, there is sometimes just form for the shape of form, some things that are purely aesthetic. But I think that when you tell a story through a song, it's always a good thing to connect it to something real, to yourself. It will be more meaningful if it's inspired by something you've lived; that will make it more original. Putting a part of myself, of my experience, into my creations is what allows me to distinguish myself from others.

all very well, but people need to try it for themselves. The first rule is to have fun, not to place the bar too high, not to get in your own way and trip yourself up; you have to go at it gradually and make sure to put fun back into the center of it all. Choose subjects that you find interesting and take advantage of the experience to get outside your comfort zone. If you choose constraints that just adhere to your own style of writing, composing, creating, that's no fun; the whole idea is to challenge yourself, but again, to do it a little bit at a time so that you don't get discouraged and give up. As with everything, there is a gauge, a cursor that you need to place, and you have to know how to do that in such a way that you can combine pleasure with efficacy.

In your everyday practice, do you sometimes feel the need to impose constraints on yourself, or is that something you reserve for specific projects?

In my everyday work, I am actually mostly intuitive. My instinct is to fall into things that I already know how to do and to use old ways of doing things. Of course, over time, I have learned to see what my creative tics are so that I can deepen my research into a particular area or move away from it if I find that it is recurring too often. But, as I said, no matter

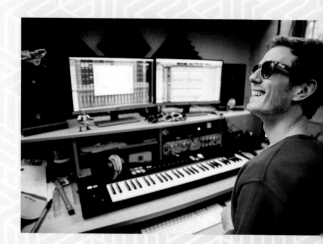

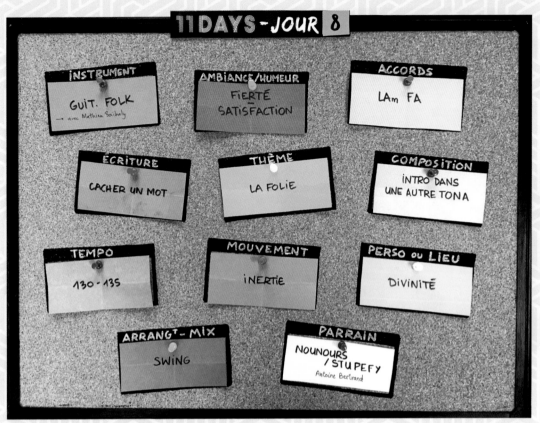

INSTRUMENT
GUIT. FOLK
→ avec Mathieu Saikaly

AMBIANCE/HUMEUR
FIERTÉ
~ SATISFACTION

ACCORDS
LAm FA

ECRITURE
CACHER UN MOT

THÈME
LA FOLIE

COMPOSITION
INTRO DANS
UNE AUTRE TONA

TEMPO
130 - 135

MOUVEMENT
INERTIE

PERSO ou LIEU
DIVINITÉ

ARRANGᵗ - MIX
SWING

PARRAIN
NOUNOURS
/ STUPEFY
Antoine Bertrand

The eleven constraints chosen at random by PV Nova for the eighth day of his challenge 11 Days. This turned into the song Lunatic Waves, with Mathieu Saikaly.

It's also important to find inspiration in what other people are doing in your field. Be careful not to fall into copying or into automatic habits; as a musician, I'm always trying to unearth new sources of inspiration.

Going out to see what other people are doing also allows me to take off my artistic blinders. For example, I don't just listen to my favorite music, I also always try to open myself to new styles, groups, languages, inspirations, and instruments, and those are all sources of nurturing.

You can definitely not invent everything overnight. There may be people who have revelations or epiphanies, but most mortals, like me, are not going to re-invent the theory of general relativity every time they create; so it's a good thing to start with what's already being done. It's also a very good way to get started.

For me, personally, if I've been able to compose, it's because I started by reproducing other people's music. That helped me to better understand the piece, what was happening, or at any rate what I liked, the harmonic changes or the use of a particular writing or compositional technique. Reproducing and recreating was what allowed me to appropriate this material, namely music, and to be less afraid of starting out into my own creations. The first things I published were definitely very much inspired by others. But then you end up freeing yourself from that. You want to create your own style, and I think that is every musician's goal, to create their own style, their own touch. When I play a piece of mine for somebody, and they say "Oh! That's you. I can hear it right away," that's a source of pride for me. You have to know how to leave your teachers behind—even though it is important to have studied their work—in order to create your own identity.

YouTube : pvnova
Site : www.pvnova.com

EXPERIMENTING

NOW LET IDEAS COME TO YOU BY GOING TO YOUR FEELINGS, YOUR INTUITIONS, AND YOUR SENSES. WITH THIS CHALLENGE AND THE NEXT ONE, IMMERSE YOURSELF IN A MORE COMPLETE EXPERIMENTATION, WITH LESS EXTERNAL GUIDANCE. YOUR PRACTICE CANNOT CONSIST ONLY OF RIGOROUS EXERCISES. EXPERIMENTING FORCES YOU TO DEVELOP A TOLERANCE FOR UNCERTAINTY. BY ACCEPTING THE ABSENCE OF STRUCTURE, YOU WILL CONNECT WITH YOUR DEEPEST SELF, WHICH WILL TAKE YOUR ART TO A WHOLE NEW LEVEL.

Tolerating uncertainty

A creative artist cannot learn all the abilities they need from exercises, nor define themselves simply by their skills, as we saw in challenges 15 and 16. Part of the creative experience has nothing to with technique and involves the realm of feelings instead. This approach is very personal and hard to explain, because it is different for everyone. The following skills belong to the realm of feelings:

- following your intuition

- accepting chance

- putting your imagination to work

- acting spontaneously

- improvising

- embracing the unknown

- playing

- surrendering to your senses

And so on. There is not really any recipe for learning how to follow your intuition or put your imagination to work. And there is no right or wrong way to do it either. To develop these skills, you just have to put yourself into the situation and try it.

If I haven't talked about experimentation so far in this book, it's because I think it's easier to tolerate uncertainty once you have a solid technical foundation. Once you have discovered your medium, feel free to experiment with moments of play (challenge 19). However, don't expect real results from your experimentations until you feel confident enough to get past technical obstacles and are able to follow your intuition 100 percent.

Following the trail

In an informal conversation with Robin Hilton and Bob Boilen on the podcast *All Songs Considered*, Paul McCartney explained his method for writing songs based on experimentation: "If I was to sit down and write a song, now, I'd use my usual method: I'd either sit down with a guitar or at the piano and just look for melodies, chords, musical phrases, words, just something to start with. And then I just sit with it to work it out, like I'm writing an essay or doing a crossword puzzle. That's the system I've always used, that John [Lennon] and I started with. I've never really found a better system, and that system is just playing the guitar and looking for something that suggests a melody and perhaps some words if you're lucky." with a little bit of luck, finding some words. Then I just tinker around that and follow the path, I try things

out and I see where they take me. Sometimes it leads to a dead end, and then I have to back up and start over on another path."

This experimental approach, which involves "following the path," can be applied to every kind of art. In what follows, we pick out some specific principles for this method.

Preparation:

◊ Don't resist, don't control.

◊ Don't think about objectives, skills, or goals.

◊ Feel free to create without judgment.

◊ Accept the random results of this practice.

◊ Create an atmosphere (with music, lights) if you need to in order to dive into the experience more easily.

Experimentation:

◊ Set a starting point: your art supplies, a palette, your idea box, or even nothing at all!

◊ Explore without trying to visualize the result from the beginning. Just develop marks, volumes, movements, or sounds by following your intuition, your feeling, and your curiosity. Push your development without trying to correct yourself. Be present and responsive to what is happening.

◊ Do you see an interesting element emerging? Follow that trail and continue to explore the element, improve it, and rework it.

◊ If you feel blocked or if your experimentation doesn't go anywhere, back up and start over with a new experimentation in order to find a new path to work on.

◊ Add and develop all of these paths together as you go along in order to end up with a finished creation.

"I begin with an idea and then it becomes something else."
–Picasso

"Do what intrigues you, explore what interests you; think mystery, not mastery."

—Julia Cameron, American artist, writer, and teacher

your Turn

Prepare yourself to tolerate uncertainty by trying out a session of experimentation where you "follow the path," using the suggestions in this challenge.

1. Start by mentally preparing for the exercise.

2. Explore a first path. If it inspires you, continue to develop it; otherwise, start the exploration process over again.

IMPROVISING

IMPROVISATION IS A COMMON PRACTICE IN MUSIC, DANCE, AND THEATER. JAZZ, FOR EXAMPLE, DEVELOPED AROUND LIVE IMPROVISATION. THIS METHOD IS LESS COMMON IN OTHER ARTISTIC REALMS BUT CAN BE EQUALLY BENEFICIAL. WITHOUT A SAFETY NET, YOUR EXPRESSION WILL IMPROVE, YOU WILL BE MORE AUTHENTIC. IMPROVISING MEANS ACCEPTING THE ABSENCE OF STRUCTURE IN ORDER TO LET GO AND FOLLOW YOUR INTUITION. AND THAT IS THE GOAL OF THIS CHALLENGE.

Accepting mistakes

Thanks to the previous challenge on experimentation, you have followed a method that pushed you to analyze your production during the course of your creative session. If some part of the experimentation did not work for you, I suggested that you explore a new path. Here, I encourage you to create without a safety net, to improvise. Imagine that there is an audience watching you. You can't say, "Oh! That's not good enough. I'll just start over!" You have to produce a performance in one take, adapting to any small failures that might occur along the way.

Improvising means directly attacking your fear of failure. Ian Parizot, a French actor and coach, explains on his blog, which is dedicated to theatrical improvisation: "I don't say this lightly: improvisation is the art of failure. Improvisation is inseparable from failure; failure is the condition of its existence." Improvising means accepting that you don't have a plan and just letting the process happen. It means accepting that you are going to act no matter what the situation, putting aside your perfectionism (challenge 7).

Chance and happy accidents

While you are improvising, concentrate on observing and listening. Involve yourself in the present moment so that you can be ready to respond to your environment. Chance will necessarily present itself if you are proactive and attentive.

> *For me, a painting is never an end nor a result, but rather a happy accident and an experience."*
> —Picasso

For me, the unpredictable interactions of water and watercolors are a good source of inspiration for beginning an improvisation.

The New York photographer Jordan Matter (see story on page 46) grounds his creative process in improvisation and chance. In every photographic session, he pulls out one detail that makes all the difference. He is not afraid of taking risks (challenge 29) in order to end up with even more exceptional situations. Because he is forced to react in the moment and with the adrenaline that results from that, he achieves an even better and more unique result.

In drawing, as well as in painting, you can also improvise. Collect your materials and just start, without being ready, without thinking. Just begin and create something, without stopping, as though you were doing a demonstration. Force yourself to react in the moment and to make decisions quickly in order to push your creation to another level.

Can you plan ahead for an improvisation?

Practice can help you acquire reflexes that will be useful during an improvisation. For instance, you can develop your observational and listening skills (challenge 11) as well as your impulsiveness. Knowing how to make a series of micro-decisions very quickly, you will improve your ability to improvise. As Michèle Taïeb, coach, actress, and author of the book *Improvising*, puts it: "Of course, it is impossible to prepare the heart of your improvisation. What it is important to prepare is the framework." Thus, you can anticipate the context of your improvisation (where, when, with whom) as well as the materials you will need. You can also use constraints (challenge 25) in order to guide your improvisation.

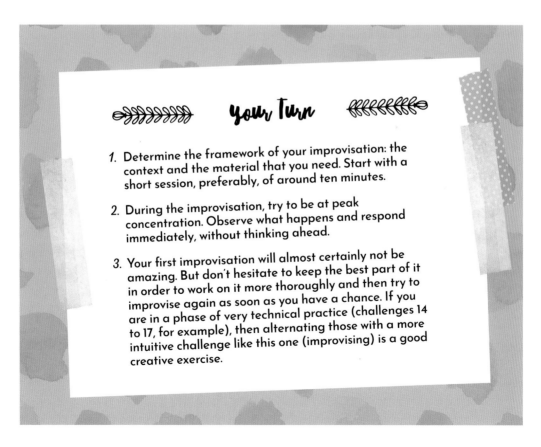

Your Turn

1. Determine the framework of your improvisation: the context and the material that you need. Start with a short session, preferably, of around ten minutes.

2. During the improvisation, try to be at peak concentration. Observe what happens and respond immediately, without thinking ahead.

3. Your first improvisation will almost certainly not be amazing. But don't hesitate to keep the best part of it in order to work on it more thoroughly and then try to improvise again as soon as you have a chance. If you are in a phase of very technical practice (challenges 14 to 17, for example), then alternating those with a more intuitive challenge like this one (improvising) is a good creative exercise.

Letting things MATURE

YOUR ART SHOULD NOT BE A SOURCE OF STRESS. YOU AND YOUR CREATIVITY CAN DERIVE GREAT BENEFITS FROM TAKING BREAKS. TAKING THE TIME TO DISCONNECT IS ONE WAY TO ALLOW YOUR WORK TO RIPEN, BUT ALSO A WAY TO DISCOVER NEW IDEAS. THE GOAL OF THIS CHALLENGE IS TO FORCE YOU TO TAKE A BREAK BY USING ONE OF THE TIPS PRESENTED HERE.

Letting things marinate

Working on a project for too long in a concentrated way is not the best way to go about things. Take time to take a step back so that you can remind yourself of your larger vision. By allowing your work to evolve this way, you also give yourself permission to think about other things. What is causing you problems at any given moment might work itself out overnight, for example, and new solutions and ideas will more easily present themselves. Instead of finalizing a project in a single session, come back to it a few times and let it steep in the meantime.

> **"Creating is a mixture of spontaneity and drive."**
> —Shaun McNiff, American artist, writer, and art-therapy teacher

Here are a few tips for taking a step back.

◦ Simply keeping your hands occupied: Alma Deutscher, the British composer, pianist, violinist, and prodigy (she was born in 2005), explained to the *Daily Telegraph* in 2016 that it was thanks to her jump rope that melodies came to her: "I don't actually jump, but I keep the rope moving while I tell myself stories...and the melodies then often just barge into my head, so I run to my notebook to write them down."

◦ Allowing yourself a moment of self-care: meditation, reading, a bath, candles, tea, music...

◦ Practicing a different creative activity or drawing on different sources of inspiration

◦ Doing sports

◦ Cleaning and organizing

◦ Getting a change of scenery, going for a walk

◦ Taking a nap

Within the rhythm of your daily life, you may often find yourself in a vicious cycle of fatigue. And you find yourself in the following situation. You want

to create, but you're tired, but you force yourself to create. In your tired state, you drag, you can't concentrate, you're not able to get anything done. You need a break, but when you allow yourself one, you feel guilty for being so unproductive. Then you go back to trying to create, but you don't produce anything, and you feel like you're wasting your time. And then you're even more tired.

I've often been in that kind of situation. The best thing to do in a case like that is to recognize that you're tired and to give yourself a rest without making yourself feel guilty. It's not as easy as it seems to admit that recharging your batteries is the most productive thing you could do. Nor should you try to optimize your rest—just take the time to be bored and do nothing.

"Don't be afraid of being bored. Be afraid of being boring."
—Cyrus North, creator of videos about philosophy on YouTube

your Turn

Take a break for a moment, setting your artistic projects aside completely, if you feel overwhelmed or fatigued. Relaxation, exercise, just going for a walk.... It doesn't matter what you do exactly, but step back from your art so that you can come back to it later with a clear and inspired mind.

PUSHING YOUR LIMITS

In the preceding challenges, you have integrated creativity into your daily life, and you already have very good experience with your art. But maybe, like me, you have started questioning your practice and your choices. Are you making fast enough progress? How can you keep improving? Are you distinguishing yourself from other artists? This is the time to get past your self-doubts and to go even farther in your artistic adventure. In this part, I encourage you to go beyond your comfort zone.

The last seven challenges of this book invite you to try out new paths, to share your art with the world, and to get some perspective in order to discover your own style.

Taking RISKS

NOW THAT YOU ARE MORE COMFORTABLE WITH YOUR CREATIVITY, IT IS TIME TO GO EVEN FURTHER. WHY NOT EXPRESS YOURSELF MORE, CLAIM YOUR STYLE, OR SELL YOUR CREATIONS? DARE TO LEAVE YOUR COMFORT ZONE AND PUSH YOUR GOALS AND YOUR PRACTICE FARTHER. TRY AT LEAST ONE OF THE EXERCISES SUGGESTED IN THIS CHALLENGE, DESIGNED TO PUSH YOU OUT OF YOUR USUAL HABITS AND MAKE YOU CONFRONT NEW CHALLENGES.

Why take risks?

You've been creating for a while. You have your habits and maybe you're even enjoying a certain level of recognition among your friends and family or your community. But you feel like you've reached a plateau in your skills—creating has become comfortable or, worse, boring. This challenge will allow you to take calculated risks in order to get beyond this stage. This is the time to renew yourself and to take a hard look at your achievements. This isn't easy, especially if you are recognized in your discipline. But it's necessary in order for creating to continue being exciting, intriguing, and thrilling to you.

There are many artists who have dared to stop and question their methods or their style during the course of their career. Carrie Shryock, an American painter, gives an example from her own process, on her Instagram account: "I don't really know how this little painting came out of my brush, but the fact is that it's here. It's different from what I usually do, but there's something about it that I really like. Recently, I've spent a lot of time trying to push beyond my own limits. As a result, I've had a lot of failures, really a lot, but sometimes also some interesting things. So I am going to let this work rest for a while and then I will see where it takes me."

Going beyond your comfort zone

Everything about your creative process can be questioned: your environment, your method, your sources of inspiration, your techniques. Using the exercises below, mix up the familiar and the unknown. Push yourself without any other expectation than to have fun and allow yourself to be surprised. Don't be afraid of making mistakes. Dive into each exercise spontaneously and judge later what it did for you.

"*Life begins at the end of your comfort zone.*"
—Neale Donald Walsch, American writer

These two landscapes were a risk for me, given that my favorite subject is watercolor flowers. I published them on Instagram, and I was afraid that the results were not up to my expectations, and that my followers would be disappointed because it wasn't my usual style. But on the contrary, they were very encouraging and appreciated the fact that I was stepping out of my comfort zone.

Exercise 1
Shaking up your habits

What are your habits? For this exercise, do the opposite of what you would normally do. Accept the mystery and the surprise involved in these experiments. Do you usually start your work in the middle? Start at the corners. Do you like figurative art? Try something abstract. Do you have a favorite subject? Try out a completely different one. Are you comfortable with constraints? This time do without them. Do you edit your photos in black and white? Concentrate on colors?

Exercise 2
Trying out a new medium

Just like Danielle Krysa (personal story on page 78), why not try out a new medium and step outside your comfort zone? If you like drawing, have you ever tried painting or photography? If you work in ink, why not try out pencil drawings or collage? This could greatly nurture your art, as explained in challenge 5. And even if you don't try out a new technique, I am certain that your own medium has not yet revealed all its secrets to you. For watercolor, for example, there are sheets with a plasticized surface, or coatings for a "paper effect" when painting on wood or canvas, that produce unexpected results.

Exercise 3
Simplifying

Take one of your creations and simplify it. Or if you prefer, choose a scene in your immediate environment and capture it in the simplest way possible. Simplifying will take you to the essence of your creation.

> *"Anyone can make the simple complicated. Creativity is making the complicated simple."*
> —Charlie Mingus, American musician and composer

Exercise 4
Working from memory

Immerse yourself in an image or a landscape for a few minutes. Then walk away from the model and create something from memory. It's not important if the result is not an exact copy. This is about bringing out your own perceptions of the object you are representing.

Exercise 5
Telling a story

It's not easy to tell a story through your art, but it gives it depth if you do (challenge 30). The story doesn't have to be a complete one; make it simple. Try to elicit the audience's curiosity. Think of a memory, an atmosphere, an anecdote, a feeling, a video, a book to inspire you.

Exercise 6
Bringing opposites together

Use two treatments at the same time that you think of as opposite in your practice. In watercolor, for instance, you could work with opaque and transparent layers together. In photography, why not choose a landscape with a very shallow depth of field, unlike what is traditionally done?

Exercise 7
Becoming a beginner again

What are the skills that you think you possess most fully (challenge 15)? As an experiment, try to approach them as though you were a complete beginner.

Exercise 8
Working fast

One of my greatest difficulties is thinking too much and having expectations of my creations. I am more comfortable making a research board (challenge 22) than improvising (challenge 27). If you're like me, make something in only ten minutes (see Jordan Matter's personal story, page 46). Knowing when to stop is one of the difficulties of this exercise.

Exercise 9
Working on your weaknesses

Fran Meneses (story page 182) suggests listing your weaknesses and working on one of them. When you are creating, what feels the hardest to you? What do you like the least? What do you avoid at all costs? These are all good starting points for this exercise.

Exercise 10
Collaborating with other artists

As challenge 33 suggests, take part in a collaborative project with other artists. Knowing that your work will be shown and that it could even become the basis for someone else's work will necessarily push you out of your comfort zone and make you improve.

Exercise 11
Sharing your creations online

Leave your comfort zone by showing your work online. It's not very hard to do, and you will probably receive encouraging feedback. Take advantage of the suggestions in challenge 34.

Exercise 12
Setting yourself a challenge

All of the exercises in this challenge are different kinds of challenges. Facing a challenge is a state of mind. It's a playful way to learn without being afraid of making mistakes (challenge 7), while having fun (challenge 19) and while pushing yourself beyond your limits. Many online challenges combine several constraints (challenge 25), in particular time, subject matter, and distribution. You can participate in an online challenge through an Instagram hashtag or a Facebook group (challenge 12, experience 15).

I am very inspired by the American fashion photographer Jessica Kobeissi, who shares a lot of challenges on her YouTube channel. I asked her which of them pushed her the farthest outside of her comfort zone, and she said, "Photographing strangers on the street! That was so stressful!" Her other ideas include: photographing with a total budget of $20 (including accessories, lighting, and model, etc.); making versions of other photographers' photographs; not giving her model any guidance; photographing in places that provide no visual interest; photographing using a Polaroid camera, and so on.

Be inventive and find challenges in order to push your creativity. This book has a lot of ideas that you can use!

your Turn

If you have the feeling that you have reached a plateau or that you are stagnating, it is time to get outside your comfort zone by trying at least one of the exercises in this challenge.

The goal is not to just do an exercise and then go happily back to your "safe" practice. Try to give yourself over to this kind of exercise on a regular basis to allow yourself to push your limits. It's up to you to decide what the best way is for you to do that; it's something you just have to get a feeling for. I'm only suggesting ways you can do it.

Take the time to think about this. What is the most frightening to you but also attracts you at the same time? That could be a path to explore.

should you stay in your comfort zone
OR LEAVE IT?

MINNIE SMALL

Minnie is an English artist based in London. She taught herself in a number of mediums (gouache, watercolors, fine-tipped felt pen, pencil, etc.) in her free time. She also has a YouTube channel, where she shares her creative adventure and her advice, as well as an Instagram account and an online store. After spending a few years building her portfolio and her online presence, she started doing her art full-time in 2016 and now makes her living at it.

Can you tell us more about your current creative process?

At the beginning, I was very rigid, and I planned everything. It almost stressed me out to think about starting something if I didn't know which direction to go or how to go about it. That probably came from the fact that I was not patient enough to paint anything more than once. A creation had to be a success the first time around; otherwise, I dropped it. Fortunately, I worked on getting away from this way of seeing things. I still don't like to work on the same subject more than once, but now I am more tolerant about what I consider to be a "success." I plan much less than before, and I take advantage of the process more. Even if I have a particular goal in mind, I let my art guide me, and I know that I will be happy with the result.

Do you have suggestions for getting outside your comfort zone and taking risks?

I don't think it's bad to stay within your comfort zone. For Inktober 2017 [Author's Note: this was a challenge started by Jake Parker in 2009, which involves making an ink drawing every day for the month of October], I only drew houses because it was a subject I was comfortable with. That helps me feel confident, and even if I make some mistakes, I know I will be happy with the result. For me, one of the joys of creating is enjoying the experience, the process, but also, if possible, the final result.

Of course, if you want to make progress as an artist, it's useful to try new things, to step outside your comfort zone. I think that the best way to approach a new subject is to try to have fun with it. Avoid being too radical and saying something like, "My work is too drab, so from now on, I have to add color everywhere." Keep up your creative habits, and then, alongside that, gently try out some new things. Start with small things, like creating a color wheel, for example, abstract motifs using new color palettes. Create just for the sake of creating, without pressure, just to try things out. That way, you may discover that actually you do like working with more color, and you will be less stressed, a little more at ease as you incorporate these new elements into your work, little by little.

Houses, 2018.

Sketchbook, 2018

I don't think that we should force ourselves to completely transform our work, to make it more complex and daring. We should be prepared to try things out, and that ought to provide the chance for us to let go, to give ourselves permission to make mistakes and to learn. Ask yourself whether you're staying in your comfort zone because you are afraid of doing something new and you don't want to make mistakes, or because you are happy with what you're doing. If your artistic process suits you well, all the better! Then it's not worth it to start big changes, just for the sake of it.

If you decide you need to start questioning your work, how do you go about it?

When I start feeling a little too comfortable in my work—even though I do believe that periods of calm are needed—I always end up losing interest in my art. That's the signal, for me, that I need to adopt a stricter approach and push myself a little: plan out a project, make sure I follow up with it, commit to studying a subject in depth a little every day, and so on.

Do you have advice for how to improve yourself?

In my opinion, you have to start by getting rid of the idea that art is simply a spiritual and sensory experience. Some people disagree with me, but I believe that an artist can be compared to a machine. We use inspiration, and then we make a product out of it— our own interpretation—a painting or a composition, whether it is intended for sale or simply for our own pleasure. At the heart of a machine is its mechanism, the combination of elements that, taken together, allow for balance and improvement. Take a high-level dancer, for example. From the outside, what we see are graceful movements, but behind the scenes, there is the repetitive training, pain, and maybe also a little wiggling of the hips in the bathroom mirror when no one is watching, just for fun.

In order to make the machine more productive, it is essential to spend some time on it. This is not original advice, but if you are not making progress, ask yourself whether you are spending enough time on it. Make your art into your routine; for me, it's every morning after I get dressed. And what should you paint? If you are bursting with ideas, if you know exactly what you want to fill up your notebook with,

then go ahead. Take advantage of these periods of inspiration. If you find yourself facing a blank page, on the other hand, that's the time to practice and learn. You can take tutorials, courses, study the masters, paint from nature, and so on. You need to apply what you learn. Spend some time using these new resources, otherwise you will always be limited by what you think you know. And even if you read all the books in the world, what you read won't sink in.

Then, I think it is key to make mistakes, to build a community so that you can receive constructive criticism, and to set challenges for yourself. For example, if you don't draw feet well, make that a challenge for thirty days. Another idea, if you want to push yourself further, is to illustrate a short story or to fill a notebook: I have a lot of suggestions on this subject on my YouTube channel. If I could only give one piece of advice, it would be that the difference between you and the artists that you admire does not come from your genes, it's not luck; it's a formula, it's a mechanism, and it's doable. Just like them, you have all the pieces of the machine at hand, you just have to start putting them together.

What are your most recent projects?

Since the summer of 2018, I have been wanting to tell stories through my art. I love documenting the trips I take, the experiences I have, capturing those memories. My project has been to illustrate a travel diary from one of my most recent escapades, a trip to Lisbon.

YouTube : Minnie Small
Site : www.semiskimmedmin.com

Fish, 2018.

CHALLENGE
30

Nurturing
YOUR SENSITIVITY

AFTER PAINTING IN WATERCOLOR FOR A FEW MONTHS, I STARTED FEELING
THAT MY PAINTINGS WERE LACKING A SOUL. I ASKED MYSELF: WHAT DOES A
CREATION DEPEND ON BESIDES TECHNIQUE? HOW CAN I MAKE IT RICHER? IN
THIS CHALLENGE, I OFFER YOU MY REFLECTION ON THIS. MY CONCLUSION IS
THAT A CREATION DEPENDS ON THREE PILLARS: TECHNIQUE, PERSONALITY,
AND MESSAGE, COMBINED IN DIFFERENT WAYS DEPENDING ON THE
SENSITIVITY OF THE ARTIST. THIS CHALLENGE WILL ALLOW YOU TO EVALUATE
YOUR SENSITIVITY AT A GIVEN TIME AND TO ASK YOURSELF WHAT DIRECTION
YOU WOULD LIKE TO GO IN.

Three creative pillars

In analyzing the work of multiple artists, I was able to discern three pillars that could be used to describe an artistic creation: technique, personality, and message. This personal analysis is necessarily subjective. You may see things differently.

The way in which these pillars are combined (with a focus on just one of them, or a balance of the three, etc.) is independent of the artistic style and the subject being represented.

Creative pillars, keywords, and examples

PILLARS	KEYWORDS	SUBJECT EXAMPLE: FLOWERS
TECHNIQUE	Practice, medium used, method, evaluation, structure, standards	"How can I draw flowers well?"
PERSONALITY	Tastes, intuition, imagination, individuality, character, emotions, letting go, present moment, memories	"What influence do these flowers have on me, and how can I express that?"
MESSAGE	Reflection, idea, message, concept, story, point of view	"What message do I want to communicate with these flowers?"

Pillar 1 - Technique

The first pillar that a beginner works on is often technique. This allows you to obtain a solid foundation, which is essential to gaining confidence. Pursuing technical excellence is not a bad thing. However, if the only interesting thing about what you've made is its perfect execution, isn't it a little empty and soulless? How will you distinguish yourself from any other artist who uses the same technique as perfectly as you do? Is there any way to differentiate between two photographers who immortalize the same scene using the exact same technique, or do they become interchangeable? I believe that they will indeed be interchangeable unless they add a little bit of personality or a message in their art (pillars 2 and 3).

> "Fine art is that in which the hand, the head, and the heart of man go together."
>
> —John Ruskin,
> British writer and painter

Pillar 2 - Personality

Are you more calm, an observer, enthusiastic, an extravert, serious, funny, or tending to anger? These aspects of your personality can emerge in your art, through your movements (as in dance or painting) or through your energy. The way that you invest yourself in your art can completely change the feelings induced in those who see or hear your work. Imagine a dance that is perfectly executed but without any personal expression: it's a perfect series of movements from a technical point of view, but is it interesting? It is not necessarily easy to express your personality in your art. It requires you to be connected with your own emotions and feelings. To help make that happen, see challenges 19, 26, and 27.

Pillar 3 - Message

The third pillar is the one that has made me think the most. Why do I create? Is my art sending a message or telling a story? No, my art is mostly decorative and ornamental; my goal, above all, is for it to please me esthetically. Is that a problem? I have come to the conclusion that it is not. You don't have to use the pillar of the message in your art if you don't want to. It's up to you to decide where you come down on this question. However, in order to make your art evolve, it is inspiring to study the point of view of other artists who do use this pillar.

> *"In art, only the quality of the artist's sensitivity counts, and art is only the means of externalization, albeit a mad means, without rules or calculation."*
> —Jean Fautrier, French painter, engraver, and sculptor

What kinds of message should you express in your work?

There are many different subjects, and they often don't have a physical representation.

You could:

◊ illustrate a point of view, a reflection, or a debate on a political, social, cultural, environmental, spiritual, etc. subject.

◊ tell a story or share an experience.

◊ present a concept or an idea.

Starting in the 1960s, some artists focused their art on the idea that it was transmitting rather than on its presentation, calling this conceptual art. In other words, they almost only used the third pillar in their expression. They abandoned visual experience in favor of reflection. In her thesis ("Conceptual art, psychoanalysis, and the paradoxes of language: a dialogue between Joseph Kosuth and Sigmund Freud," 2017), Fernanda Pereira Medina explains it this way: "Simply put, the basic idea of conceptual art is the idea that artists are working with meaning rather than with form, color, or material." Joseph Kosuth is one of the major figures of conceptual art.

Food for thought:

BELIEFS · CULTURE · DEATH
DESTINY · DIFFICULTIES · DREAMS
ENVIRONMENT · EXCESS · FAMILY
FEAR · FREEDOM · FRIENDSHIP
FUTURE · HAPPINESS · INTOLERANCE
JUSTICE · KNOWLEDGE · LOVE
MADNESS · MEMORY · NOSTALGIA
POLITICS · RELIGION · REVOLTS
SCIENCE · SOCIAL MOVEMENTS · SOCIETY
SOLITUDE · SPIRITUALITY · SUFFERING
TIME · TRADITIONS · WAR · YOUTH...

Telling a story

Even if you don't go as far as using only the third pillar, it can still be interesting to include it in your art. The simplest way to begin this exercise is to tell a story. The Swedish painter and illustrator Camilla Engman explained to the website Fast Company in 2015: "The human brain seems to want to understand things. If you put two things together, it immediately starts to think about why and what. For me, that makes up a story."

In a discussion with Youngman Brown for the podcast *Your Creative Push*, Alex Strohl, a French adventure photographer based in the United States, claimed that telling a story is more important than technique. "We all have a unique story to tell. If you spend time working on what makes you different—and only that—I think that you will push your art to a new level.... If it has life in it, if the reason why you took the photograph shines through, then it doesn't much matter whether it's overexposed, underexposed, or blurry. It may be

a cliché, but I think that the goal is to concentrate on the story that needs to be told."

Don't beat yourself up if your art is just decorative, or if, on the other hand, it is too political or conceptual. Just try to follow your own curiosity (challenge 10) and be authentic (challenge 31). It is up to you to decide how you want to implement the three pillars in your practice. Telling stories and sharing ideas with your art is not absolutely necessary, and it requires time and confidence.

Sunny backyard, watercolor and colored pencil on paper, 2017.

Through her drawings, Ira transmits her vision of the world. The realism of a particular scene is not what interests her the most; she freely mixes the real and the imaginary.

City park, watercolor and colored pencil on paper, 2016.

Ira's illustrations immerse the spectator in a poetic story and universe (see her story on page 64).

Spotlight on Carrie Shyrock

The American painter Carrie Shryock shared this reflection on her Instagram page: "The other day, I heard someone saying, 'If the subject of your art is only what it represents, then it probably isn't art.' I'm not sure if I agree, but it made me think. Recently, I've been trying to understand the meaning of all of these landscapes and skies that I paint. I ask myself what shape they should take, how they should evolve. I know that I really like large open spaces because of my childhood on the Missouri prairie. That's part of me. I like feeling very small in a huge, magnificent landscape. I was in New York these last few weeks and I felt the same feeling there, but in a very different way. I think about that a lot. That same person also said, 'Art is when you take the thing that is most important to you and give it a shape. That's a challenge. That should be a challenge.' Yes, I approve."

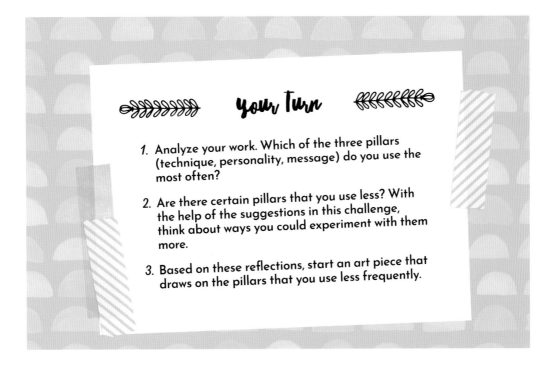

Your Turn

1. Analyze your work. Which of the three pillars (technique, personality, message) do you use the most often?

2. Are there certain pillars that you use less? With the help of the suggestions in this challenge, think about ways you could experiment with them more.

3. Based on these reflections, start an art piece that draws on the pillars that you use less frequently.

Discovering
YOUR OWN STYLE

STYLE IS A TRUE CREATIVE QUEST. EVERY ARTIST HAS ASKED THEMSELF: "HOW DO I FIND MY STYLE?" I HAVEN'T BROUGHT UP THIS TOPIC SO FAR IN THIS BOOK BECAUSE I BELIEVE THAT STYLE IS THE RESULT OF PRACTICE AND TRAINING. YOU NOTICE IT, RATHER THAN GOING OUT TO FIND IT. THROUGH YOUR PRACTICE, AND BY MEETING THE CHALLENGES THAT HAVE BEEN OFFERED TO YOU IN THIS BOOK, YOUR STYLE WILL UNAVOIDABLY EXPRESS ITSELF. THIS CHALLENGE INVOLVES HIGHLIGHTING IT.

Style as a consequence of your work

If you're just starting, don't think about your style. Concentrate instead on your training. "When you're thinking about your style, you always write badly," wrote the French writer Rémy de Gourmont (*Promenades littéraires, cinquième série*, "Le style et l'art de Stendhal" [Stendhal's Style and Art], 1913). As you create, follow your curiosity, open yourself to multiple influences, get perspective on your work, and begin projects. Your style will form itself.

The American photographers and writers David Bayles and Ted Orland, in their book *Art & Fear, Observations on the Perils (and Rewards) of Art-making*, write: "Style is not an aspect of good work, it is an aspect of all work. It is the natural consequence of habit." As you learn and practice, you will accumulate preferences and habits, and this challenge will help you to discover them. The American artist, illustrator, and writer Lisa Congdon confirms this vision in an interview with the blog Outlier: "Even though I worked hard for years to forge my own style, I wasn't actually progressing towards the style that I ended up discovering. Getting there took years and lots of experimentation, trial and error, and work in order to try to differentiate myself."

Observing your work

One way to discover your style is to observe your work. Take out the last things you created and observe them, comprehensively and holistically. What are the common threads? Are they a result of your creative habits (where you find your ideas, how you mix them, what your artistic sensitivity is, etc.)? Observe the repetitions, in particular, and notice what you do automatically. This could have to do with how you work on color, shapes, motifs, subject matter, and so on. If you haven't already done it using challenge 20, list your strengths. Do most of your creations use your strengths? And likewise, in the creations that you find less good, can you see reflexes that are not helping you and that you could maybe get rid of?

In order to highlight your style more clearly, you could revisit one of the first things you created. Your style has evolved since then, and you will be able to see that by comparing the older creation with your recent work.

Winter coat, by Emma Block, 2018.

Emma's creations are delicate and joyful. Her favorite mediums are gouache and watercolor.

Alfama, by Emma Block, 2017.

Spotlight on Emma Block

"The way that I found my style is the same as for most artists, I suppose: by producing a whole lot of work and by varying my sources of inspiration as much as possible. Everybody has a style, just like everybody has their own handwriting. The more work you do, the more your style will emerge and the more confident you become. Of course, you shouldn't fall into the easy way out; don't try to be like someone else by copying their style and their work."

Instagram : @emmablockillustration

Site : www.emmablock.co.uk

Peruvian women by Emma Block, 2017.

Emma draws inspiration from the people she meets in her daily life; old photographs, movies, or clothes; her travels; illustrations from the 1950s; 1930s jazz; and dachshunds.

You may find that the people around you urge you to make changes: "Why don't you try some new subjects?" They may not be aware of all the challenges that your favorite subject poses for you, and all they see is "the same thing over and over." Don't be afraid to keep exploring the subject for as long as it intrigues you. On his blog, the American watercolorist Stephen Blackburn talks about this issue: "I'm not saying that your style should be reserved for one subject alone, but concentrating on one subject is a good way to allow your style to emerge. I now use the style that I'm known for on all sorts of subjects, but I started developing it by concentrating on landscapes and trees, and then flowers."

"Specialization makes everything so much easier."

—Alex Mathers, British illustrator and writer

Choosing a favorite subject

When starting an artistic practice, many people choose a favorite subject to focus on. In painting, it's often landscapes, cityscapes, portraiture, animals, the sea, still lifes, and so on. For me, it's watercolor flowers. Exploring your favorite subject is a way to forge your style. Your preferred subject captivates you and spurs you on; it seems inexhaustible. By lingering on it, you take the time to study its subtleties and difficulties. You move beyond the initial stage of technical apprenticeship that is necessary for any new medium or subject, and you connect with your style through your experimentation.

Being authentic in order to differentiate yourself

In order to truly advance towards your own style, you have to be authentic. Don't ask yourself too many questions like "Am I too scattered?", "Will people like this?", "Is it original enough?" Embrace every part of your art and be yourself, even if that scares you. As I described it in challenge 10, follow your curiosity and have fun. In your practice and your research, push out far, without constantly comparing yourself to others. Take the time to be alone and dedicate time to your art in order to build your process on your own, following your inspirations. What is your impact? How do you

transmit your essence through your art? Dare to reveal yourself and allow your vision to shine through in your art in order to set yourself apart.

Revisit Danielle Krysa's suggestions for finding your style in her story on page 78.

> *"You'll never make authentic art if you aim to please."*
>
> **–Enrique Martinez Celaya, artist and physicist**

 your Turn

Take a moment to take stock of your style and find out where you stand.

1. Collect a number of the things that you have made and observe them. Look for common threads and for strengths. You can also redo one of your earliest creations in order to get a better sense of how your style has evolved.

2. In order to find cohesion in your work, concentrate on one favorite subject for a period of time. Go into it in depth, get beyond the technical difficulties, and dare to experiment.

3. Are you able to be authentic? Use the following questions to help you understand better:

 - When you observe your creations, can you say, "That's definitely me!"?
 - Do you feel your own imprint on your work, or do you instead still see too much of what has influenced you?
 - Do you have the impression that you are trying to please someone with your art, even subconsciously?

Constructing a unique style
BY REJECTING THE RULES

KIANA UNDERWOOD

Kiana, who is based near New York, is the creator of Tulipina, an internationally renowned floral studio that offers custom-made services for weddings and spectacular events. Kiana has a unique way of combining flowers and colors, which she teaches in workshops around the world. In 2018, she published a book, Color Me Floral, on monochromatic compositions. I was intrigued by the steps she went through in the construction of her style, and that's what she reveals to us in this personal story.

Can you tell us more about the evolution of your career?

Up until about eight years ago, I didn't really think of myself as creative at all. I grew up in California in the middle of flowers and magnificent gardens, and I took it for granted, I didn't realize how lucky I was. I studied international relations because I wanted to travel. After I graduated, I moved from the East Coast (Washington, DC), where I had done my studies, back to San Francisco. There, there were not a lot of opportunities in the international relations field, and I found myself in a job that was not very inspiring or fulfilling, in a think tank at Stanford University. When my first child was born, it was not very hard for me to quit, and I did it with no regrets. I became a full-time stay-at-home mother with three children under the age of five, and I loved spending time with other mothers and their babies and having them over to my house. I always had flowers at my house, and the other mothers often admired them. One day, when my youngest was starting kindergarten, my husband suggested that I try floral design as a business. I thought that it was ridiculous. There are so many florists in this world, why me?

But I had nothing to lose, so my husband and I put together a website, and I made my debut in the world of floral design. Every week, I went to the San Francisco Flower Mart, the city's most beautiful flower market, and I explored this new world that I had dived into. I started to really love it. I was creating arrangements and learning a lot. Gradually, I began to discern which flowers and which styles I liked best:

that's how the adventure of Tulipina began. I shared my work on Instagram, and that definitely opened doors for me and gave me opportunities that I would not have had otherwise.

What is your creative process like now?

I get a lot of inspiration from simple things: a walk in the garden, a beautiful flower, a visit to a museum, a piece of music that I like. My business is made up of two main activities: creating the floral decorations for weddings and luxury events, and teaching, both of these all over the world. I really love both of them, and especially the international aspect, because that allows me to continually stimulate my creativity in order to remain unique. Flowers and the way that they are arranged can be very different depending on the country, and that's really inspiring to me.

Your style is very distinctive. How did you develop it? Do you have any advice to give about that?

I am a very persistent person. In my quest for a unique and personal style, I tried to push the limits of what most people consider to be the norm, I tried to leave that behind. That helped me to set myself apart. I think that in order to be good at something, you have to be willing to work hard, be consistent, and—especially in a creative field—to keep learning so that you improve and renew your creativity, rather than just maintaining the same level.

So how do you go about trying to improve yourself?

In the world of Instagram and its abundance of visual stimulation, I feel as though my work often gets copied. I think that's a shame. I've never understood that way of doing things because, for me, it's just the opposite: I am proud of being myself and of the fact that I don't copy others. At the beginning, it bothered me, but I finally decided I would just constantly reinvent myself and look for new opportunities. That opened up an entirely new field of possibilities for me and helped me to improve myself.

What are your current projects?

In addition to weddings and workshops, I'm working on new projects all the time. The most recent major project was my book, *Color Me Floral*, which I wrote in a year and which came out in March of 2018. It was a lot: a lot of work, and there were a number of problems to overcome, but now that it is out, I can say that it has had a terrific reception. Since then, I've been working on developing an estate that I bought in upstate New York. I plan to create beautiful gardens there, as well as a place where I can teach people from all over the world.

Instagram : @tulipinadesign
Site : www.tulipina.com

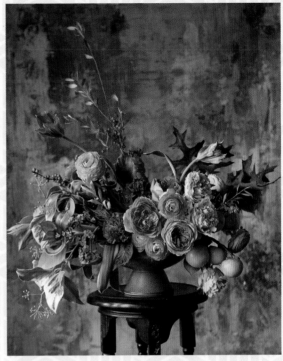

2017. Her compositions, which look natural and even accidental, require a lot more effort than it might seem!

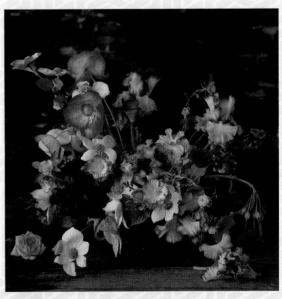

2018. Color plays a central role in her work. Kiana likes to go against the trends and create unexpected combinations.

Creative SURVIVAL KIT

THE ARTISTIC PROCESS IS FULL OF PITFALLS. IN SPITE OF YOUR GOOD INTENTIONS WHEN YOU START OUT, YOU WILL SOMETIMES GET DISCOURAGED AND ASK YOURSELF, "WHY AM I DOING THIS?" THIS CHALLENGE OFFERS YOU A NUMBER OF SUGGESTIONS FOR DEALING WITH THE MOST COMMON PROBLEMS THAT CREATIVE PEOPLE ENCOUNTER. IN ORDER TO OVERCOME THEM, I CHALLENGE YOU TO TAKE A NOTEBOOK AND RECORD YOUR DIFFICULTIES THERE.

Normal and helpful negative moments

The nature of the creative process is to be made up of highs and lows. Whether we like it or not, our creativity feeds on the moments of insecurity and the inevitable difficulties that we overcome. Look at all of these phases, both positive and negative, as the pieces of a puzzle. When everything is lined up right, properly combined, and forms the final product, you experience a kind of magic, a flow, a fantastic creative zone that is hard to describe. Be patient. Didn't Churchill say, "Success consists of going from failure to failure without loss of enthusiasm"? Isn't it precisely the fact that it resists you that makes you appreciate the creative process?

> "When obstacles arise, you change your direction to achieve your goals, you do not change your decision to get there."
> —Zig Ziglar, American writer and motivational speaker

The contents of the kit

This first-aid kit will be helpful to you in the most common difficult situations that creatives deal with. Are you feeling a deep discomfort, or is it just an excuse? Don't expect to just be pitied and comforted in your negative phase—surround yourself with people who can help lift you up. If there aren't any such people around, refer to the kit whenever you need to!

"I'm not inspired...motivated...in the mood."
"I can't create anything. I'm blocked."

Don't wait for inspiration or motivation. You will find them in the process of creating. As the American painter and photographer Chuck Close suggests, "If you wait around for the clouds to part and a bolt of lightning to strike you in the brain, you are not going to do an awful lot of work. All the best ideas come out of the process; they come out of the work itself."

Here are several helpful ways to proceed.

◗ Create, even if you are less ambitious with it. Julia Cameron, the author of *The Artist's Way*, has this reassurance to give: "Creating does not have to always involve capital-A art. Very often, the act of cooking something can help you cook something up in another creative mode. When I am stymied as a writer, I make soups and pies."

◗ Channel your negative energy as a source of inspiration. If you're brooding, why not make a large abstract India ink painting reflecting your state of mind?

◗ Use constraints (challenge 25).

◗ Have fun (challenge 19).

"I'm under too much pressure."

Following the example of challenge 28, allow yourself to take breaks in order to rest and get rid of your stress. The idea that wasn't coming to you may appear when you are in the shower or while you are jogging. Remember to keep your "willpower reservoir" in mind. It is full at the beginning of the day, but it gets emptied as the hours go by and chores and fatigue pile up. And notice that if you have chosen to create at the end of the day, you might find yourself experiencing the limits of your willpower.

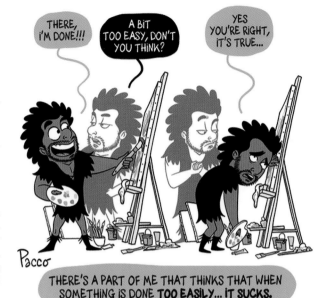

No pain No gain *by Pacco, 2018.*

"I'm never going to get anywhere, so there's no point...."

Be persistent in order to improve your art over the long term. Have faith in your ability to improve without giving in to your fears and without finding excuses. Remember that you promised yourself to overcome all that at the beginning of your creative adventure (parts 1 and 2). Stay positive: with a little bit of self-mockery, laugh at your mistakes if you have to in order to redirect your natural instinct telling you to stop. "There is only one possible mistake: deciding not to create," says Danielle Krysa on the blog, The Jealous Curator (story on page 78).

"The work I do is not up to snuff."

We all have a little voice inside us judging us. It's particularly loud for perfectionists. And unlike external criticism, it sees both the process AND the result.

> "Perfectionism doesn't believe in practice shots. It doesn't believe in improvement."
>
> —Julia Cameron, American artist, writer, and teacher

Keep the following pieces of advice in mind.

◔ You don't need other people's approval (challenge 1).

◔ Try to live your creativity in the moment instead of trying to anticipate everything. Don't let your expectations block you; embrace the unknown and your mistakes as being for the best!

◔ Nurture your store of influences (challenge 14), learn to mix and combine them (challenge 21), and aim for authenticity (challenge 31) rather than looking for originality at all costs.

"I'm not legitimate."

You may suffer from impostor syndrome (challenge 4). You spend your time comparing yourself with other people, and you feel suffocated by their work. Yours seems ridiculous to you, and you don't feel legitimate. It doesn't matter whether or not you've had training in art or not, whether you're too young or too old: everyone can create something and has something to contribute.

"I'm bored." "I'm not making any more progress."

As you were able to see with challenge 30, you may have reached a plateau. You've mastered your subject, you want to protect what you're known for, you're not looking for inspiration anymore, you're not exploring anymore: you're bored. Think about what Picasso said: "Success is dangerous. One begins to copy oneself, and to copy oneself is more dangerous than to copy others.... It leads to sterility." It is you yourself who are limiting your own progress.

There are several possible solutions.

◔ Give yourself permission all over again to make mistakes. When you start never making mistakes, you don't feel like making new ones. But if you never fall down, you never make progress (challenge 7).

◔ Learn a new technique. Try out a new medium (challenge 5).

"I'm just unlucky."

Sometimes, unfortunately, you just can't help it: the power goes out, your laptop gets stolen, your arm is broken.... Faced with the unexpected, tell yourself that everything happens for a reason. What doesn't kill you makes you stronger!

 your Turn

1. If you find yourself in a difficult phase, take a notebook and use it to write down all your problems. Don't try to write beautifully. Just jot down your thoughts as they come to you.

2. For every problem, try to find a solution, or at least get some perspective.

3. Don't show what you've written to anyone and don't reread it.

4. Start writing again as soon as you feel bad, every day if possible.

sharing and COLLABORATING

AT FIRST, IT ISN'T ALWAYS EASY OR COMFORTABLE TO SHARE AND COLLABORATE WITH OTHER ARTISTS, BUT IT WILL BRING YOU MANY BENEFITS. KNOWING THAT SOMEONE ELSE IS LOOKING AT YOUR WORK, YOU WILL GIVE YOUR BEST, AND THE QUALITY OF YOUR ART WILL BE BETTER FOR IT. I SUGGEST HERE FOUR SIMPLE KINDS OF SHARING AND COLLABORATION: COLLABORATIVE PROJECTS, CREATIVE PARTNERSHIPS, MENTORING RELATIONSHIPS, AND ARTISTS' MEETUPS. SHARING WITH OTHER ARTISTS WILL ALSO ALLOW YOU TO DEVELOP YOUR NETWORK AND TO MAKE YOUR ART KNOWN. SO, CHALLENGE YOURSELF TO CONTACT AN ARTIST TO SUGGEST ONE OF THESE FOUR KINDS OF COLLABORATION TO THEM.

1. Collaborative project

In certain artistic fields, like cinema, the theater, and music, where it is difficult or impossible to put together a project alone, collaboration is a natural part of the creative process. In those situations, tasks are distributed based on different specialties (for the movies, for instance, there's the cameraman, editor, costume designer, actor, director, producer, etc.). Even if your art is of a more solitary kind, like painting or photography, I encourage you to work on a collaborative project.

Contact one or more artists and decide on a project where you can join your skills. Ideally, you should be proactive and give ideas. It could be a matter of creating a painting together or working on a video, an installation, an exhibit, or something else. The possibilities are endless. Whether it is something you do for pay or a personal project, if you do it in collaboration, you will surely produce something more complex and ambitious than what you would have produced on your own.

If you don't quite dare to create something working together with several people at the beginning, then you can start by choosing a shared project where you work separately but compare your creations at the end. A challenge can lend itself well to this kind of format, like what PV Nova did (story on page 132).

At any rate, by leaving your comfort zone in this way, you will learn a lot about other people's techniques, processes, and points of view. You will be inspired, filled with energy, and your art will reach a new level. In addition, this kind of project will allow you to better get to know the artists you are connecting with and potentially to make yourself known among their community.

2. Creative partnership

Your creative adventure will be made up of highs and lows. It's a great thing to have a creative alter ego, with whom you can share what you're going through. That person can also be an accountability partner for you: you can take on the responsibility of a mutual commitment to lift each other up, encourage each other, and support each other.

Just talking to your partner about your projects will help you make them more concrete. Sometimes, all you need in order to find a solution

to your problems is to articulate them out loud. Check in with your partner on a regular basis in order to see where you are and what you've done. Your productivity will shoot up like an arrow, and you will quite naturally create a routine that is difficult to break because you will be committed to each other.

Being a part of a community, through a forum or a Facebook group, for example, can also play the role for you of having a creativity partner. But it's more effective to designate one or two particular people. Among your friends or family, is there someone who might have goals that are similar to yours? Or if you don't know anyone, send out a message among your community letting people know that you're looking for a partner for mutual creative encouragement. I'm sure you'll find someone!

3. Mentorship

You don't have to discover and learn everything all by yourself. Someone else has already gone down that road and might have the answers to your questions. In reading artists' stories and biographies, I realized that most of them have or had mentors. Unlike a creative alter ego, a mentor has several years more experience than you do. A mentor can advise you, guide you, and also push you to give your best, sometimes with some constructive criticism.

How do you go about finding a mentor? In an interview with the website The Great Discontent, the American painter Elle Luna explained that one day she sat down to write out some bold lists, including "Dream Mentors," "People with Magic Powers," and even "Things to Do before I Die." She was daring enough to write to the people on her lists and was astonished when one of them suggested having lunch the following week.

In this day and age, when we can write to almost anyone electronically, dare to contact your dream mentors, while staying realistic (avoid celebrities). Also accept that a quality relationship takes time to build, and that it is a two-way street. Think about how you can help your mentor in your own way (see page 172).

> ## "Mentoring is a two-way street. You get out what you put in."
> —Steve Washington, American entrepreneur

4. Artists' meetups

Artists' meetups are a way to meet other artists and share with them just for pleasure. Choose a place and time and make a date to meet at a cafe, in a park, or at a museum to create together. There may already be groups in your city that meet regularly in order to create together. Urban Sketchers, for example, is a network that exists almost everywhere in the world and that organizes meetings between devotees of drawing, sketching, and travel notebooks. Participating in this kind of get-together is a way to relax and talk with other artists without expectations or comparisons. It's a low-pressure way to develop your network and to break out of your isolation if that is weighing on you.

In order to find this kind of group:

- start by asking about groups that might already exist in your town or city;

- become active in a Facebook group specializing in your favorite medium and (with the group moderator's permission) ask other members of the group if they would be interested in a local artists' meetup;

- ask your friends to spend some creative time with you, even if they don't practice the same art form as you.

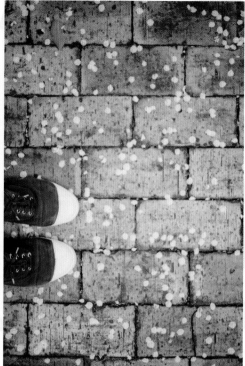

^ *Élise's photos*
www.lisebery.com

My photos >

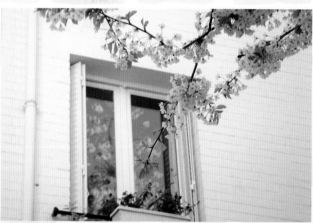

Juliette's photos >
www.jenesaispaschoisir.com

One place, four interpretations

In 2016, I suggested a collaborative project to three other Parisian photographers, Élise, Marie-Charlotte, and Juliette. The goal was to photograph the same place and then to compare our pictures and our experiences. We shot a total of four locations, one for each season. Each person's preferences in terms of subject matter, framing, light, and treatment come through: here you see our photographs of Paris's *Cité florale* (an idyllic floral village in the 13th arrondissement) in the springtime. The similarities and differences provoked interesting discussions that taught me a lot about photography.

v *Marie-Charlotte's photos*
www.mariecharlottephotographie.com

Seven tips for networking effectively

Be informed

Before contacting one of your idols, make sure that you are well acquainted with their history and their current activities. Respond to their work on social media, and don't hesitate to share it. In the content of your message, concentrate on the person you are writing to, showing them that you know their work and mentioning the specific projects that have made an impression on you. There is no need to say too much about yourself.

Don't hesitate

You have nothing to lose in contacting the artists that you admire. The worst that could happen is that they could ignore your request (consider asking again) or turn you down. Likewise, don't be afraid to start a conversation in person with someone you meet at an event. If you don't know how to approach them at that moment, try to guess what they might be thinking (it could even be as simple as "Nice buffet, isn't it?"), and stay relaxed.

Prepare yourself for refusals

Whether you're looking to start a collaborative project or organize a simple get-together, you will have to deal with multiple refusals. Be prepared for that, while still remaining confident.

Give before you receive

Whatever form the artistic sharing takes, everyone should get something out of it, not just you. Be clear on what the advantages of the collaboration are for everyone. Depending on who you're approaching and for what kind of connection, consider offering your help before anything else. Even if you feel like you have nothing to offer (to a mentor, for example), you surely have resources in some other realm. Use your imagination!

Be specific

Make sure to give your interlocutor important details in order to convince them to collaborate with you. Show them that you have already thought about the best way to share and that you are organized. In particular, be prepared with an estimate of the time that your proposed collaboration will take, any costs, and the benefits.

Listen

Listen to your interlocutor, and ask questions about what intrigues you.

Make yourself visible

In order for people to be able to contact you and to know your art, you have to make yourself visible, findable. Share your work, talk about it at events. Start with your family and friends, then develop your online presence (challenge 34). If sharing your work comes naturally to you, opportunities for sharing and collaboration will be more plentiful and interesting!

In particular, revisit Courtney Cerruti's advice on how to network in her story on page 26.

 your Turn

1. Put together a list of ten artists whom you admire and with whom you would like to share or collaborate.

2. Of the four types of collaboration presented here (project, creative partnership, mentorship, or meetup), which is the most immediately interesting to you?

3. Think about three ways to collaborate with the artists you have chosen, and choose the one that you like the most.

4. Contact the artist or artists that would be involved in your idea, using the ideas given above for networking effectively. This may be the beginning of a beautiful creative adventure for you!

sharing
YOUR CREATIONS
online

ARTISTS TODAY HAVE A HUGE ADVANTAGE OVER THEIR PREDECESSORS: THE INTERNET. SHARING YOUR WORK ONLINE IS A SIMPLE WAY TO IMPROVE. IN THIS CHALLENGE, DISCOVER THE ADVANTAGES OF THIS KIND OF EXPOSURE, ALONG WITH A LIST OF BEST PRACTICES SO THAT YOUR ONLINE EXPERIENCE CAN FULLY NURTURE YOUR ART. I PURPOSELY LEFT THIS SUBJECT FOR THE END OF THIS BOOK BECAUSE I BELIEVE THAT AT THE BEGINNING OF YOUR PRACTICE, IT IS IMPORTANT TO CREATE FOR YOURSELF AND TO EXPERIMENT AWAY FROM THE GAZE OF OTHER PEOPLE. NOW, THOUGH, DARE TO SHARE A CREATION OF YOURS BY CREATING AN INSTAGRAM ACCOUNT, A BLOG, A WEBSITE, OR AN ONLINE PORTFOLIO.

Why share your work online?

This approach has numerous advantages. Opening up your creativity to the outside world will, in fact, improve your:

◊ **progress:** Sharing encourages you to push yourself in order to do the best you can. That also allows you to improve other skills of yours that are indirectly connected with your art (such as photography, computer skills, etc.);

◊ **expertise:** By sharing your knowledge and your experience as you are learning, you will reveal yourself as being more of an expert than someone who has never tried. You will, therefore, certainly start receiving questions;

◊ **stimulation:** As you see other artists sharing their work and you begin to see reactions to your own, you will want to share more experiences. That will give you even more energy for continuing your work;

◊ **confidence:** In spite of what people sometimes say, online feedback is often kind and encouraging. The first comments you get will surely reinforce your self-confidence;

◊ **network:** The internet will allow you to gradually build a community. Finding people who have the same passion as you is extremely nurturing, motivating, and inspiring. It is also an opportunity to meet wonderful people;

◊ **career:** Sharing your work online is the best way to make yourself known today if that's what you are looking for. It allowed me to transform my pastime into a professional project.

Spotlight on Courtney Cerruti

On the benefits of sharing what you've learned, whether online or elsewhere, Courtney Cerruti writes: "Ever since I was a student, and now professionally, I share a lot of my knowledge, either through courses or in workshops. It's very gratifying. I never hesitate to openly share everything I know, really everything, and the more I do it, the more I learn. Teaching helps you to master your art. You have to see it through your own eyes but also through the eyes of your students, and this constant dialogue allows you to evolve and grow."

See Courtney's story on page 26.

The author's website: The French title means "Marie's trials and tribulations." Tabs across the top include Home, Blog, Free Courses, Watercolor Courses, My Book, and Find Out More. On the blog, you have the option of seeing my most recent articles, or choose All articles, Watercolor tutorials, Art supply reviews, Watercolor tips, Creative tips, Inspiration, Videos, News. The specific blog titles shown include Mistakes to avoid for watercolor flowers; New video class: Fantastic Flowers; My watercolors are blah!; Hints for painting watercolor flowers; and Why Is Copying Not Enough?

What should I share?

You have several options, including:

◊ **a blog or a website:** This is a long-term project and requires the most investment. Your website needs to have new content added regularly and offer something of value to the reader in order to be discovered by search engines or Pinterest. This is the most professional option, especially for building a portfolio;

◊ **Instagram:** This social network, which is based on the images that are trending at any given time, allows you to share more spontaneous videos, which will disappear after twenty-four hours (called stories). **This is the simplest way to share your creations that I can suggest;**

◊ **Facebook:** The main advantage of Facebook is in the possibilities it offers for joining discussion groups and sharing groups. For example, I recommend the group "Ateliers de DESSIN - Renata" ("Creative workshops with Renata"), in which Renata suggests new ideas every week for drawing easily, along with many challenges;

◊ **YouTube:** This video platform has more and more viewers every day. The video format gives you a different way to share your art and your personality. However, the quality of the videos, overall, is very high, which can be discouraging when you are starting out;

◊ **specialized platforms:** Depending on your art form, you might find it worthwhile to share your work on specialized platforms, such as 500px or Flickr for photography. These two sites allow you to share your photos, make comments, find inspiration, and participate in discussion groups.

What should I share?

You can share a variety of content, depending on your preferences: inspiration, workspace, process, finished creations, creative reflections, doubts, reviews, advice, and so on. However, in terms of sharing content, only share what you are comfortable with. Shaun McNiff, an American artist and the author of *Trust the Process: An Artist's Guide to Letting Go*, points out that not all art needs or ought to be shared: "Can you imagine people feeling that their prayers, spiritual exercises, and meditations must be exhibited in a gallery or commercially published? This simple distinction between primal exercise and commercial production describes the fundamental values of my approach to making art."

Facing your fears

Sharing your art with strangers often provokes the same kinds of fear for most people:

◊ **Fear of having nothing of interest to share and not being good enough:** Don't be afraid of being too much of a beginner to share something. There will always be someone less experienced than you who will be interested in your perspective and your experience.

◊ **Fear of being copied, of having your secrets or your art stolen:** This is indeed a risk, but there are ways to protect your creations once you have reached a certain level. More generally, sharing your techniques will bring you more opportunities than headaches. You will position yourself as an expert and develop interest in your discipline.

*Sofie Dossi, American contortionist, in the New York City subway
for a ten-minute photo challenge with Jordan Matter, 2018.*

Spotlight on Jordan Matter

"Online, you choose what you share. It's important to show both your successes and your failures at the same time, not just your successes. People have to see that making a mistake is not a bad thing if you want to create, in fact quite the contrary! For me, it's all the more important because most of my audience is young, and therefore very easily influenced. My next challenge is to use my YouTube channel to have a positive influence on the life of the people who follow me. I would like to offer new kinds of videos where I celebrate individuality, sharing with deaf dancers, overweight dancers.... I want to show that it's a good thing to step out of the mold where everyone has to be like everyone else."

See Jordan's story on page 46.

◌ **Fear of not being able to stick with it long-term and of dropping the ball:** Trying doesn't commit you to anything. If you like it, you can establish a rhythm that works with your schedule, and if you can't manage it, too bad!

◌ **Fear of becoming addicted and not creating for yourself any longer:** This is definitely the biggest risk. You have to create in order to have content to share, but that should not be an end in itself. Make your priority be your own experimentation and practice, not the internet.

Developing your online presence

Don't feel obliged to get all of this set up in a systematic way. You can choose to share your experience periodically, and that's fine too. If you want to go further and improve your online visibility, take advantage of the suggestions below, which were very helpful to me.

Quality and relevance

Pay attention to the quality of what you publish (photography and writing) and try to offer the greatest value possible (experience, advice, etc.) Limit yourself to photographs of your own creations: if you share content on too many different subjects, you run the risk of alienating your audience, which will then lose interest in your art.

Regularity

Be regular. That's the most important piece of advice. If you decide to share one blog article a week, one image a day, or one video a month, try to stick to that. It is by creating a rhythm that you will collect a community, which will count on your regularity. The time that you dedicate to publishing should not, however, keep you from unplugging in order to be able to recenter yourself in your art.

Engagement

If you appreciate the reactions and comments that you are getting, take the time to answer and engage in the discussion. Even if it takes time, keep your community animated, show an interest in other artists' work, answer questions, and so on.

Vulnerability

Show your vulnerability on social networks. It's definitely not easy, but share your mistakes and your moments of doubt. Your community will recognize itself in these difficulties and will see you as a "normal" person. Your followers will open themselves up to you in response, which will help you as well. By showing that you're not perfect, you will reinforce the relationship of trust you have built with them.

Chasing "likes"

Publishing on social media is addictive. "Likes" and comments give you immediate gratification and a burst of adrenaline. This can cause you to create for the sake of getting likes and to evaluate your work based on how much response you get when you publish it. But the creative process is made up of stages, and sometimes they take time. Social networks, on the other hand, push you to go fast and publish a lot. Don't fall into the trap of chasing likes. Take the time and the perspective that you need to develop your art, as the most important thing. Don't force yourself to create only what gets positive responses on your networks. Ask yourself: Are you happy with your art? Are you enthusiastic about it? If not, you may have reached a plateau. Take risks, reactivate your curiosity, and become a beginner again. This may disorient your community, but in order for your creative activity to be sustainable, it is you who have to like it, most of all (challenge 32).

 your Turn

1. If you haven't already done it, use this challenge to start an online creative adventure. Create an Instagram account or a blog, or join a Facebook group, and share your first creation online.

2. If you're already online, ask yourself how you can go to a higher level, and use the suggestions in this challenge to improve your visibility.

Displaying your difficulties online
WITHOUT HIDING YOUR VULNERABILITY

FRAN MENESES

Fran is an illustrator who has been based in New York since the summer of 2018. She's from Chile, where she spent a creative childhood designing her own toys. Although she studied graphic design, Fran realized that illustration was actually her future. She taught herself, and after a few years working as a designer, she became a full-time illustrator. She is currently dedicating her time to her YouTube channel, where she shares creative advice and documents her daily life, as well as to her online store, where you can find posters, stickers, journals, and her most recent book, About to Leave (2018).

Since 2013, you have been sharing your creative adventures and your advice on YouTube. And, in particular, you give an unvarnished look at your difficulties (lack of motivation and inspiration, self-doubt, etc.). Does that help you to get some perspective and to get through those moments better?

It's true that most of the time (if not all the time), I share my struggles [giggles]. Thanks to YouTube and Instagram, I have a better sense of how much time progress takes, because I have the visual proof. I tell myself that it's important that other people know about my self-doubts. When I see very talented artists who do not share their weaknesses, I tell myself, "Oh, they're so professional!" And then I start to question again my decision to expose my own struggles. But finally, I get so many messages from my followers telling me how helpful it is to them that I keep doing it. We are human. We have the right to make mistakes.

And in fact, sharing content online does help me get perspective. It's a lot like a kind of intimate diary that I've been keeping now for about two years. I like monologuing in writing: just writing down my thoughts, without thinking, without judging whether they're coherent, just putting them down on paper. That helps me to notice the repetitive elements or the things that need improvement. And it's exactly the same thing with sharing my adventure as an illustrator online.

Creative process, an essay, 2017.

How do you manage to push your limits and stay fresh?

It's a lot easier to push yourself when you're working with clients. The results have to be good because the client is paying, and you want to impress them. But when you're working on your own projects, as I now mostly do, it's harder. I try to impress myself, or my community. It's easy to make your little internal voice shut up and stay inside your comfort zone. Because, let's be honest, it's annoying, exhausting, and discouraging to work on our weaknesses. But for me, it's necessary so that I can keep creating good products, illustrations, or videos. The advice I can give is to make a list of all the things that you're not good at (in your creativity but also in your personal life) and to make them into priorities. And of course, there, I start with the element that seems the most important and that will have the greatest impact.

What would you say is the most important piece of advice for a self-taught creative to keep in mind?

I recently got a message from someone who wanted to quit their job to start a full-time illustration career. At the end of the letter, they asked me, "Fran, should I quit?" That made me anxious, almost paranoid. I didn't want to tell her to do something that she would later regret. Everything takes time, whether it's a career as a lawyer, an artist, or a nurse. When you watch some people find success in less than a year, you may not realize all the hidden work that went into that success. I get a lot of comments saying things like "Your success came so fast, that's fantastic!" But...I have been doing this for more than ten years! People only see the tip of the iceberg, and that's understandable. I know that this isn't the advice that people want to hear, but...you have to be patient. Developing your art will take time and work. If you like what you're doing, relax and enjoy yourself. You will learn a lot about yourself. Make a cup of coffee, surround yourself with books and people that lift you up, go to a museum, try new techniques, and enjoy the ride, because most of the time, you're going to be riding alone. If you want to be successful, to develop an audience, for example, you'll need time. You can't establish that bond of trust in two months.

Ophelia, 2016.

Sorry for being a creep, 2018.
Fran's little comic strips highlight her weaknesses.

YouTube : Fran Meneses
Instagram : @frannerd
Site : frannerd.etsy.com

facing CRITICISM

OPENING YOURSELF UP TO CRITICISM IS HARD. WHAT IS A CRITIQUE BASED ON? ACADEMIC THEORY, AN ARTISTIC TREND? EVERYONE HAS THEIR OWN VISION OF WHAT SUCCESS OR FAILURE IS: CRITICISM IS SUBJECTIVE BY DEFINITION. THE ART CRITIC PIERRE COURTHION SAYS, "EVERY PAINTER IS MISSING SOMETHING. IT'S INEVITABLE." AND YET, OPENING UP YOUR ART TO OUTSIDE PERSPECTIVES CAN SOMETIMES BE VERY HELPFUL. HEARING WHAT YOU DON'T WANT TO HEAR, IF THE CRITICISM IS CONSTRUCTIVE, CAN HELP YOU IMPROVE. THIS CHALLENGE INVITES YOU TO PRESENT YOUR WORK TO THREE PEOPLE AND TO ASK THEM TO GIVE YOU THEIR FEEDBACK.

Exposing yourself to criticism

Only give yourself the opportunity to receive criticism once you feel ready for it. There's no point in shaking your budding confidence by opening yourself up to the opinions of people who have probably never created! Being ready means being willing to question your art, being ready for change, while still holding onto your own judgment. It is up to you to decide whether or not to accept the criticism you receive and to use it. Even if it has merit, the simplest thing might be to ignore it if you are not yet ready to hear it.

Once you are ready, try to get a variety of perspectives on your work. I suggest that you make a point of asking other artists first, because it will be easier for them to put themselves in your shoes, and the criticism they give will be more constructive. The opinion of artists outside of your own usual practice can also be very interesting, because they aren't that familiar with your art and its rules. This kind of critique can be a turning point that allows you to visualize, question, or reaffirm the project you're working on. Remember that you will probably get a lot more positive than negative feedback, so don't be afraid.

Daring to submit your work to criticism will surely force you outside of your comfort zone, but it will also bring you great benefits if the criticism is constructive.

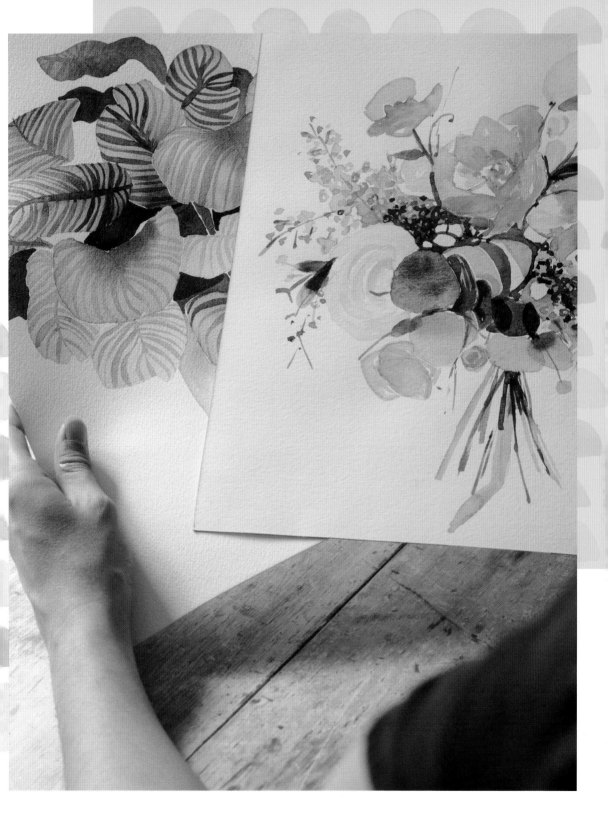

Spotlight on Minnie Small

"It was very hard for me to find the right balance online so that I could allow my experimentation to coexist with the world of critiques, some of them unasked-for, that you open yourself up to. I would guess that that's true for most artists. I believe that it's important to share not just your good work but also your less good work within an open and understanding community. Most people who follow me do not hesitate to share their own difficulties and self-doubts, and so they are grateful when I do the same. I have also learned that I don't have to share absolutely everything. That may seem obvious, but it was liberating for me. I put less pressure on myself knowing that I can have quieter days when I try things out, just for myself, not having to submit myself to other people's opinions."

Receiving constructive criticism

Most of the time, you will get critiques without having asked for them. First of all, ask yourself whether the criticism is constructive, or whether it will only hurt you. Constructive criticism is given within an environment of trust. The person first talks about the positive aspects, and then moves on to what might need improvement. The goal is to help you improve. Listen to it without trying to defend yourself or immediately blocking yourself off. Don't be too attached to your work but stay positive. Even if what you have made is not tremendously successful, it is still surely useful for your own progress.

That doesn't mean that you have to accept every piece of constructive criticism that you receive. Follow your gut and your own judgment in evaluating how relevant the feedback is. Sometimes, an outside critique will not be helpful to you at all.

"Getting a compliment is fabulous, but bouncing back after a thoughtful and constructive criticism is what pushes an artist forward."

—Sarah K. Benning, British embroiderer

Responding to unasked-for criticism

What should you do when you receive gratuitous negative criticism? You could respond in several different ways:

◊ **Put it in context:** How do you deal with this kind of criticism outside of your artistic activity, as a parent or an employee, for instance? Why not use the pedagogical or management methods of communication that you have developed for matters of creativity as well?

◊ **Ignore it:** You can't concentrate on both your artistic performance AND what other people think. Give your art priority and ignore other people's gratuitous opinions.

◊ **Surround yourself:** Surround yourself with your dream team—family and friends—who will support you, no matter what, when you doubt yourself.

◊ **Stay active:** Go back to creating right after any gratuitous negative critique. It shouldn't stop you: stand firm in your own desire to create.

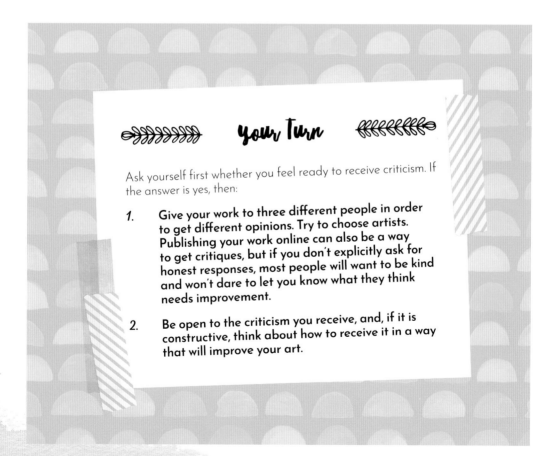

your Turn

Ask yourself first whether you feel ready to receive criticism. If the answer is yes, then:

1. Give your work to three different people in order to get different opinions. Try to choose artists. Publishing your work online can also be a way to get critiques, but if you don't explicitly ask for honest responses, most people will want to be kind and won't dare to let you know what they think needs improvement.

2. Be open to the criticism you receive, and, if it is constructive, think about how to receive it in a way that will improve your art.

CONCLUSION

The creative process is shaped like a spiral. With the thirty-five challenges in this book, you have experienced a constant and changing exploration. Now that you have come to the end of it, don't hesitate to go back to the beginning to discover a new practice, deepen your existing one, or just create your own path. Push the limits of your creativity even further and build an overall vision. Now try to start a complex project combining several of the challenges: brainstorming (challenge 13), a research phase (challenge 22), a series (challenge 24), experimentation (challenge 26), setting yourself a challenge (challenge 19), and sharing with your community (challenge 34), for example. This will give even more depth to your art.

Make the challenges in this book your own, and week by week, year by year, create your own process. Allowing your art to mature will take more time than you wish it would and will bring up doubts and frustrations.

At times like that, remind yourself that those kinds of difficult moments are essential for making progress. Push further in your exploration and discover realms of the creative process that I have not discussed in this book. As you move along in your practice, transformations will happen and aha moments will appear. Your process is never finished, and it will evolve along with you. As soon as it seems like it's finalized, you will probably question it again. It is this very complexity that makes it so fascinating.

In his interview with Pierre Courthion, *Chatting*, Matisse returns to this subject, talking about a conversation with the painter Carrière: "'But, my friend, that is what you are working for. If you had already arrived, you would probably not work anymore. That is your reason for working.' In painting, as in every kind of art, what we are trying to achieve is to reconcile what is irreconcilable. Within each of us, there are all kinds of qualities that contra-dict each other. And using all of that, we have to build something viable, something stable. That is why we work all our lives and why we want to work until the last minute, if we haven't run away, if we haven't lost our curiosity, if we haven't settled into routine."

Reconciling the irreconcilable. That is ultimately what the creative process requires. Joining improvisation with reflection, vulnerability with confidence, mistakes with pride, research with intuition, personality with technique, communication with focus on oneself.

I hope that this book, which condenses in its pages everything that I have learned so far, guides you to search for that balance and inspires you to constantly renew yourself.

BIBLIOGRAPHY

David Bayles and Ted Orland, *Art & Fear: Observations on the Perils (and Rewards) of Artmaking*, Image Continuum Press, 2002

Julia Cameron, *The Artist's Way*, TarcherPerigee, 10th Anniversary edition, 2002

Charles Duhigg, *The Power of Habit: Why We Do What We Do, and How to Change*, Cornerstone Digital, 2012

Hal Elrod, *Miracle Morning*, John Murray, 2016

Elizabeth Gilbert, *Big Magic: Creative Living Beyond Fear*, Riverhead Books, 2016

Daniel-Henry Kahnweiler, "Huit entretiens avec Picasso" [Eight interviews with Picasso], *Le Point*, n° 42, October 1952

Jonathan Kis-Lev, *Masterwork: a Guide for Writers, Musicians and All Artists on Turning from Amateurs into Masters*, CreateSpace Independent Publishing Platform, 2016

Austin Kleon, *Steal Like an Artist: 10 Things Nobody Told You About Being Creative*, 1st edition, Workman Publishing Company, 2012

Danielle Krysa, *Creative Block: Get Unstuck, Discover New Ideas. Advice & Projects from 50 Successful Artists*, Chronicle Books LLC, 2014

Jim Leonard, *Your Fondest Dream*, Vivation Publishing, 2012

Elle Luna, *The Crossroads of Should and Must: Find and Follow Your Passion*, Workman Publishing Company, 2015

Carol Marine, *Daily Painting: Paint Small and Often to Become a More Creative, Productive, and Successful Artist*, Watson-Guptill, 2014

Henri Matisse and Pierre Courthion, *Chatting with Henri Matisse: The Lost 1941 Interview*, edited by Serge Guilbaut, Tate Publishing, 2013

Shaun McNiff, *Trust the Process: An Artist's Guide to Letting Go*, Shambhala, 1st edition, 1998

Steven Pressfield, *The War of Art*, Black Irish Entertainment LLC, 2011

Denys Riout, *Qu'est-ce que l'art moderne?* [What is modern art?], Folio Essais, 2000

Steve Simon, *The Passionate Photographer: Ten Steps Toward Becoming Great*, New Readers, 2011

Michèle Taïeb, *Improviser* [Improvising], Eyrolles, 2015

Twyla Tharp, *The Creative Habit: Learn It and Use It for Life*, Simon & Schuster, 2003

I warmly thank my family, my partner, and my friends who have supported me in this major project. Thanks to my editor, Nathalie Tournillon, who provided guidance and pushed me to go further and further. Many thanks as well to Anaïs Nectoux and Françoise Barat for their advice and suggestions, which were very much appreciated.

Thank you to the subscribers to my website, Les Tribulations de Marie, for the interest they have shown for the creative process through my newsletter Explore! over the years, and for their kind support.

My thanks go as well to all the artists who granted me some of their precious time to tell their rich stories and who shared pictures of their creations. As a long-time admirer of their work, I was particularly touched by this generosity. Thank you, then, to Juliette Becquart, Shari Blaukopf, Emma Block, Courtney Cerruti, Elise Charlot, Yao Cheng, Marie-Charlotte Guisset, Danielle Krysa, Josie Lewis, Jordan Matter, Fran Meneses, Pacco, PV Nova, Deeann Rieves, Minnie Small, Ira Sluyterman van Langeweyde, and Kiana Underwood.

ACKNOWLEDGMENTS

About the Author

After working for three years as a renewable-energy engineer in Paris, Marie Boudon decided in 2017 to start her business working in watercolors, a medium that she finds fascinating. Since then, she has been offering fresh, modern video courses on her website. Bringing together her work and her passion, teaching herself, and professionalizing her art have not always been easy. She realized that the questions she had about the creative process were questions that many other artists shared, no matter what their history or their specialty, which gave her the idea to write *Dare to Create*.

Visit her site: tribulationsdemarie.com

Instagram: @tribulationsdemarie

YouTube: Tribulations de Marie